MICHAEL SINGER

MICHAEL SINGER

by Diane Waldman

This exhibition
has been made possible
by funds provided by
Barbara and Donald Jonas
and a grant from the
New York State Council
on the Arts.

Solomon R. Guggenheim Museum, New York

Library of Congress Cataloging in Publication Data

Waldman, Diane.
 Michael Singer.

 Bibliography: pp. 81-82
 1. Singer, Michael, 1945- — Exhibitions. I. Singer,
Michael, 1945- . II. Solomon R. Guggenheim Museum.
III. Title.
N6537.S56A4 1984 709'.2'4 84-1422
ISBN 0-89207-045-5

Cover

foreground:
Cloud Hands Ritual Series 1983. 1983
Granite and fieldstones, 26 x 105 x 64"
Collection of the artist, courtesy
Sperone Westwater, New York

background:
First Gate Ritual Series 1982.
1982 (cat. no. 46)
Installation view, artist's studio, Vermont

Published by

The Solomon R. Guggenheim Foundation, New York, 1984

LENDERS TO THE EXHIBITION

Diane and Steven Jacobson, New York

Barbara and Donald Jonas, New York

Paine Webber Inc., New York

Felice and Edward J. Ross, New York

Michael Singer

Sidney Singer

Yale University Art Gallery, New Haven

Sperone Westwater, New York

ACKNOWLEDGEMENTS

This exhibition would not have been possible without the support of Barbara and Donald Jonas and the assistance of the New York State Council on the Arts, for which I am deeply grateful. I am also indebted to the National Endowment for the Arts, Barbara and Donald Jonas and Diane and Steven Jacobson for donating funds for the purchase by the Guggenheim Museum of Singer's *Ritual Series 80/81*, 1980-81. My sincere thanks are expressed to those who have generously lent drawings to the show and have thereby significantly contributed to its success. Acknowledgement is also due to Sperone Westwater for its important help in realizing the catalogue.

On behalf of Michael Singer I would like to thank Jake Colgan at Granite Importers Inc., Barre, Vermont; William Marcrow at Vermont Structural Slate Co., Inc., Fair Haven, Vermont; and Don LaCroix at Dorsey Memorials, Amherst, Massachusetts, for their special attention. The artist's appreciation is also expressed to those who have assisted him, including Dick Davis, Chris George, David Greenblatt, Tom Korns, Chris LaRosa, David Poses, Steven Siegel, Mark Shapiro and Darryl Zeltzer. His special acknowledgement is made to Alec Martin for technical advice.

I greatly value the efforts of Guggenheim Museum staff members towards the realization of both the exhibition and the catalogue and would like to single out those who have been most centrally involved. My special gratitude is owed to Susan Taylor, Curatorial Coordinator, who has worked intelligently on all phases of the project; Carol Fuerstein, Editor, for her perceptive editing of the catalogue; Diana Murphy, Editorial Assistant; Guillermo Alonso, Assistant Registrar; and Riquita Stoutzker.

Finally, my deep appreciation is extended to Michael Singer; working with him has been both an enjoyable and rewarding experience.

D.W.

MICHAEL SINGER

by Diane Waldman

The first sculptures by Michael Singer to receive major exposure were exhibited at the Guggenheim Museum in *Ten Young Artists: Theodoron Awards* in 1971 (cat. nos. 1,2). They consisted of steel or milled wood beams placed in delicate, precarious balance. Although the works seemed casual in construction, the equilibrium upon which they were based was the result of thoughtful deliberation, experimentation and change. These apparently contradictory characteristics have continued to preoccupy Singer over a thirteen-year span, during which time he has produced an impressive body of indoor and outdoor sculpture, an accomplished series of drawings, site-related photographs and, most recently, a portfolio of etchings and lithographs.

Central to the development of Singer's sculpture has been an exploration of the principles of balance, movement and of the nature of materials. As I stated in the text accompanying the Theodoron exhibition:

> To maintain a stable position in a straightforward manner, Singer has aligned a series of individual units into constructions in which each segment is mutually interdependent on every other one. The work is complicated to a further degree: nearly all his sculptures have the capacity for movement; as a result a potential for disorder is imminent since no two poised elements are joined together. Although Singer uses a number of different materials — wood, steel, rattan, etc. — he manipulates them all to conform to a common vision. He imbues a weighty, solid material like steel with properties of flexibility and lightness, thus making it appear no heavier than the rattan, whereas the rattan seems equal in weight to the steel.

> The act of motion within a single piece necessitates the presence of a participant ... [possibly] a mere chance situation in which the piece is touched accidentally, for example, by the wind. Although the weight is evenly distributed, any overly forceful action can threaten the controlled state of equilibrium....With the introduction of motion there is a heightened awareness of the nature of the material — as it is and as it is transformed into another context through a transcendence of the medium.[1]

The work of these formative years evolved out of the Minimalist aesthetic, which then dominated advanced artistic circles. The cool aloofness that characterized Minimalism is epitomized by Carl Andre's floor-related pieces and Robert Morris's equally understated pale plywood sculptures. Subsequently, Richard Serra challenged the Minimalist disengagement of sculpture from spectator by proposing a more direct confrontation between viewer and object in his lead-prop pieces. The influence of Minimalism is visible in Singer's work in his choice of such materials as steel, bricks or milled wood and in his reliance on these materials to dictate form. Yet Singer's sculpture lacked the extremely rational ordering, the uniform emphasis and stability that characterized Andre's floor pieces and Morris's sculpture, and the sooty, gritty aggressiveness of Serra's more flamboyant work.

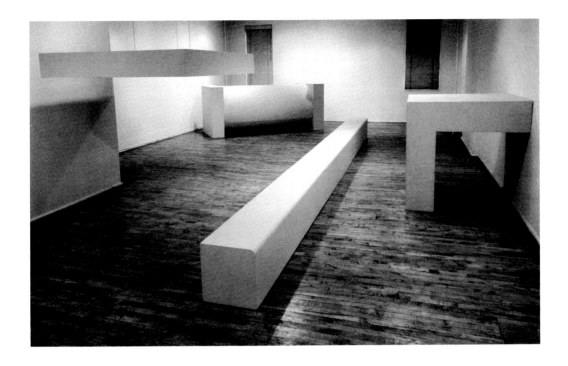

Already discernable in Singer's art of that period was an interest in issues that would clearly distinguish his style from the reductivist mode of the Minimalists of Andre's and Morris's generation of the mid-1960s, which filtered down into the work of Serra and his colleagues. It was evident that Singer differed not only from his immediate predecessors but also from his contemporaries such as George Trakas, Alice Aycock and Mary Miss, whose work was architectonic, and other artists whose overriding emphasis on gesture resulted in the virtual exclusion of formal considerations. Clearly Singer shared with other young sculptors an interest in material and process. However, his acute feeling for form, his striving to achieve the essence of simplicity, the poetic evocation of an art, which, even in its earliest stages, questioned the validity of an expression based exclusively on aesthetic issues and sought to resolve the contradictions among man, culture and nature, set his work apart and mark it as unique.

In order to place Singer's work in perspective, it is essential to recapitulate certain events that preceded his emergence as a young sculptor in the 1970s. In the mid-1960s a number of important shows, notably Morris's exhibition at the Green Gallery in late 1964 (fig. 1) and Andre's installation of sand-lime bricks at Tibor de Nagy in 1966 (fig. 2), had a radical impact on subsequent develop-

9

fig. 2
Carl Andre
Installation view, sand-lime bricks, *Equivalents*,
Tibor de Nagy Gallery, New York, 1966

fig. 3
Carl Andre
144 Pieces of Steel. 1967
Hot rolled steel
Formerly Stroher Collection, Darmstadt, West
Germany

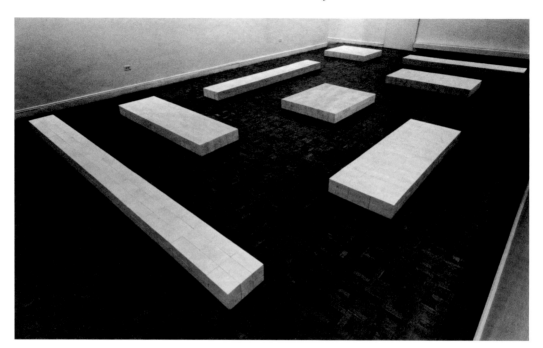

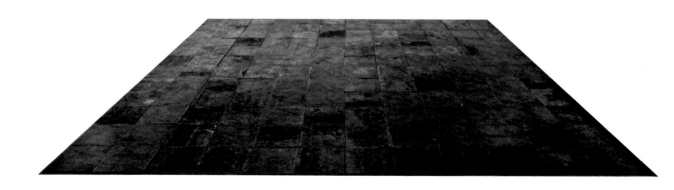

fig. 4
Richard Serra
Splashing. 1968 (destroyed)
Lead

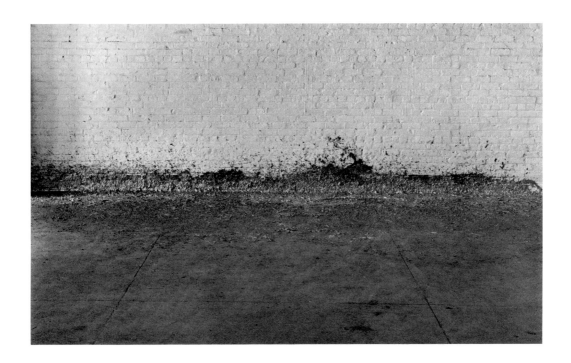

ments in sculpture. Morris's simple geometric plywood forms with their pale gray uninflected surfaces had no internal relationships but instead related to the viewer and the surrounding space. Andre's allover works (both the brick installations and the later metal-plate pieces [fig. 3]) were, in his own words, as level as water. These emphatically flat pieces, set directly on the ground, identified the floor as their plane. The sculpture Morris and Andre showed in these exhibitions was central to the development of the Minimalist aesthetic.

Although artists such as Andre and Morris, as well as Donald Judd, Dan Flavin and Sol Lewitt continued to make important contributions, by the late 1960s younger sculptors, including Serra, Bruce Nauman, and Keith Sonnier, began to react against what appeared to be the excessive formalism and geometry of Minimalism. Serra and others experimented with gesture and process; in their work a shift of emphasis emerged, as emotional and spontaneous responses began to predominate over carefully considered rational concepts and cool logic. In a momentous exhibition, *Nine at Castelli*, held at the Castelli Warehouse in 1968, Serra showed *Splashing* (fig. 4), an arresting wall-and-floor-related environmental piece made especially for the space. Serra created it by throwing molten lead against the wall, thus emphasizing action in a manner recalling Pollock and the

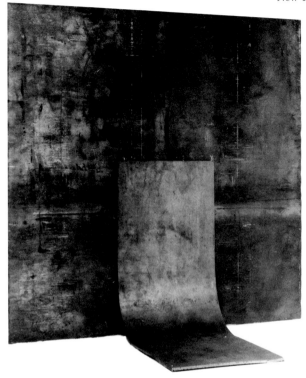

Action Painting of the late 1940s and the 1950s. More typical of Serra's works of the period were his lead-prop pieces in which gravity, balance and wall and floor planes were integral compositional elements (fig. 5). He used materials such as lead antimony whose raw look and malleability, which enabled him to roll planar configurations into curved or tubular forms, offset an otherwise unyielding geometry. Since the components were extremely heavy and were literally props, two unattached units dependent upon one another for stability, they brought an element of extreme precariousness to the work and constituted a threat to the spectator and an imposition upon the environment.

Like Serra, Singer chose to balance his pieces tenuously. However, because Singer's sculptures rest fairly close to the floor, the element of danger present in Serra's work is virtually nonexistent. Singer's interest in balance appears to have been stimulated not only by Serra's example but also to have evolved in response to issues that had been confronted by many twentieth-century sculptors. Brancusi's various formulations of the *Endless Column* of 1918 to ca. 1920 have no bases. They represent his rejection of the traditional separation of figure and base — a problem that was further addressed in David Smith's sculpture from the 1950s on, for example *Cubi XXVII*, 1965 (fig. 6), Anthony Caro's ground-related painted-steel constructions of the early 1960s, such as *Midday*, 1960

12

fig. 6
David Smith
Cubi XXVII. 1965
Steel
Collection Solomon R. Guggenheim Museum,
New York

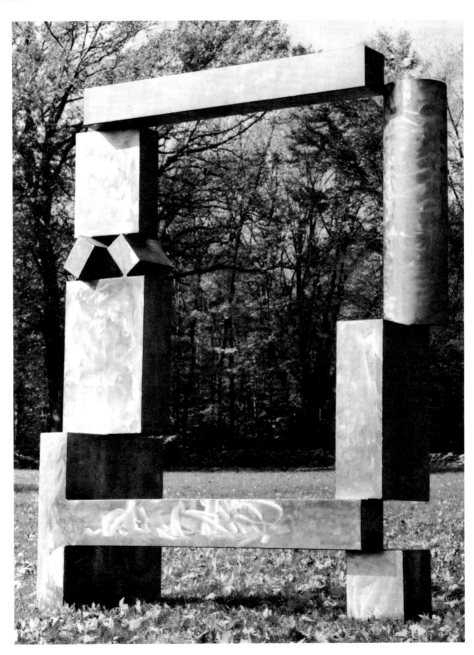

fig. 7
Anthony Caro
Midday. 1960
Steel painted yellow
Collection The Museum of Modern Art, New York,
Mr. and Mrs. Arthur Wiesenburger Fund

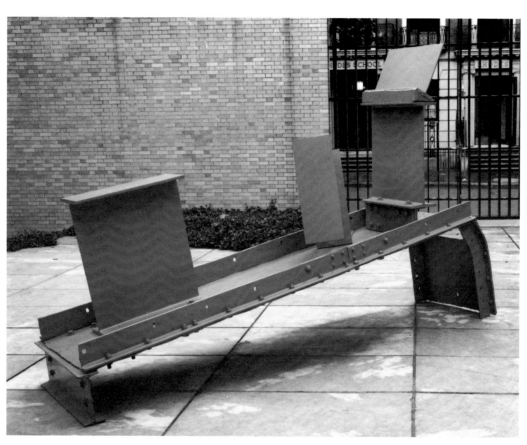

(fig. 7), and Andre's floor-hugging brick and metal-plate pieces of the mid-1960s. By the late 1960s and early 1970s, as artists redefined sculpture, balance, propping, stacking and alignment were among the means they favored to articulate form. Thus, in his early work *Balance XXIV*, Spring 1971 (cat. no. 1), Singer uses stacked lead fire-bricks as the support structure for his milled wooden beams; these, in turn, are counterbalanced by additional bricks that act as weights to stabilize the sculpture.

For a young artist like Singer the period of the late 1960s to early 1970s represented both an end and a beginning: the rational, formalist approach was winding down, giving way to an idiosyncratic, highly subjective vision. An antiformalist attitude towards materials and structure predominated in young artistic circles. Largely abandoned, or so it appeared, were many of the issues that engaged sculptors during the 1950s: the articulation of figure and base, of truth to materials, of appropriateness of sculpture to place. Wood, lead, rubber, rope, cotton batting, Masonite, fabric, barbed wire, leaves, hemp, gravel, ashes, sandbags, were scattered, strewn, randomly assembled on the one hand, or propped, stacked, aligned into a semblance of architectonic order on the other.

However, Singer was from the outset more selective than most young artists of the period in his choice of materials. And his evident sense of the appropriateness of his materials came from an understanding of place. In New York, where he lived and worked on the Lower East Side, wood, steel and brick seemed most fitting for pieces related to an urban setting. Yet other materials — rattan and bamboo — fascinated him as well. Singer recalls using rattan and bamboo as early as 1969. Inspired by his direct experience of the saltwater marshes of Long Island, where he grew up, and *National Geographic* articles about Thor Heyerdahl and the people of Lake Titicaca, Peru, Singer began to assemble grasses from the marshes and truck them to the studio.

Singer explains:

Heyerdahl theorized that ancient Egyptians and Peruvians took ocean voyages in enormous reed boats. His theory is partly based on the fact that both of these cultures built similar papyrus boats. It was the reeds that fascinated me. I wanted to gather reeds and bunch them as a material to look at in the studio. An available reed in this region is phragmites, which I gathered from the Long Island saltwater marshes. I used jute rope to bind thick and thin bunches of the reeds.[2]

Singer located the bamboo and rattan he needed for his experiments in warehouses in New York and New Jersey. He speaks of the seminal importance of his encounter with the story of Heyerdahl's journey across the Atlantic in a reed boat and the description of the Peruvian culture:

There is a remarkable harmony between the people of Lake Titicaca, Peru, and their environment. These people live off the papyrus reeds that grow in the region. They create floating islands from these reeds. Their houses, boats and food supply also come from these reeds. Their mythology reflects their dependence on the reeds and the enormous lake. I wanted to understand this kind of harmonious relationship of vision and life-style of a culture to its environment.

Works such as *Balance XXIV* are very much about the city and the barriers, grids and confined spaces that typify an urban environment. Yet Singer's use of rattan and bamboo and the tripod forms he created with these plants in the 1970s clearly indicate that he was not entirely satisfied with the city as a source of inspiration or with materials appropriate to an urban site.

The questioning of his situation was in part inspired by his contact with Allan Kaprow, who had come to Cornell in the spring of 1964, during Singer's freshman year at the university. During the late 1950s and early 1960s, Kaprow had a wide artistic influence, generating ideas and sparking experimentation in a variety of media. Singer performed in one of Kaprow's most notable Happenings, "Household"; he was so impressed with Kaprow that he received permission to leave Cornell during his junior year to study with the artist at Stony Brook University on Long Island. Kaprow subsequently introduced Singer to Marcel Duchamp and Joseph Cornell. While he greatly admired all three, Singer recognized that their direction was not his own. However, Kaprow represented an alternative to formalists such as Mondrian and Giacometti, whom he had studied at college, and to painting, which he had pursued as an undergraduate. And ultimately it was the example of Kaprow, who continually experimented, who was concerned with chance, with time, with process and materials rather than with the finite object, that prompted Singer to remove himself from an art world and a city he found stifling and distracting to the seclusion of the country.

Although Singer continued to maintain his own loft on the Lower East Side, he established his primary residence in a small town in Vermont in 1971. Singer's approach to his new environment was tentative. He began by placing one of the large steel balance sculptures he had brought from New York in the fields near his rented house. Then he started to alter the configurations of the piece. Singer recalls:

> I found myself making changes and then looking at the work through a camera. It dawned on me that I needed the camera to re-create the framework of the walls of my city studio and that I was being strongly influenced by the urban vision and experience that I had just left.

> It was an important lesson for me to realize that in this different natural environment vision isn't blocked, there are no grids. In the pastoral and wooded landscape of Vermont, vistas open to valleys and mountains, and it's the atmosphere that veils and reveals the hills over great distances. It was this natural environment that I wanted to understand.

In Singer's first years of living away from the city he was primarily preoccupied with two environments: the beaver bogs (cat. no. 6) in Marlboro, Vermont, where he worked from 1971 to 1973, and the saltwater marshes of Long Island. During the three winters Singer worked in the bogs, he observed the ecology of the site and the work patterns of the beavers there, and his sculpture resulted from his consideration of the shifting forces of nature. As he says:

In the bog the working material was the trees. I cut dead trees and rigged up all kinds of devices to move them through the woods, to build a structure with them. The guiding principle of these structures was balance. Each "situation" would be completed when the set of trees, leaning on one another, was balanced to a point of weightlessness, a point where, through the use of stumps as fulcrums, one could gently touch a part of this structure and feel the entire assemblage move.

I wanted this to look accidental, unintended, as though a work of nature. There was to be no human presence; perhaps because I was still trying to understand what my own presence in this natural environment should be. I cut trees so they would split as though a windfall caused such an occurrence. I painted many of the cut ends to conceal the whiteness of the raw wood. It became an absolute rule that there should be no sign of human presence. Part of my obsession about the absence of humans in these works came from the shame I felt about being part of a culture that has systematically destroyed the natural environment. Western culture views man at the top, controlling nature, apart from it. When nature is conquered, confined, controlled, man is safe. In order to experience and learn from the natural environment I felt the need to yield to it, respect it, to observe, learn and then work with it. This early rule that I had, to not allow my presence in the work, was helpful in this yielding and learning process. Eventually I accepted my role in the environment as more than observer, manager, researcher. I understood this role as an artist.

Singer remained committed to the concept of working alone in nature. Although it now appears rudimentary in view of his recent development, this work brought him into his first direct contact with nature. By accepting nature and its innate laws, he was allowing the surroundings to act on him rather than imposing himself on the environment. In this important respect alone he differed from many of his contemporaries who, working within the idiom of Earthworks, had simply imposed studio-related art onto the landscape. These sculptures eventually predicted the works that were to come. More importantly, making them gave Singer an opportunity to learn about his materials and a chance to work out process in a private rather than public context.

During the period he worked in the beaver bog, Singer also studied the saltwater marshes of Long Island. Here he was intensely involved with the vastness of the space and with the ecological patterns of the marsh in relation to the life cycle of the area. Already apparent was the concern with ritual and Oriental prototypes that was to remain a major preoccupation. The sense of balance and peace, the spiritual aura of the works evokes Far Eastern sources and ritual objects. As he had earlier formed grasses into bunches in his studio, now he shaped bundles of phragmites (marsh reeds) into curves; these he set into bamboo structures that he placed like totemic markers in the great open landscape. The structures were positioned so they caught the ever-changing patterns of light that moved across the landscape. Singer notes that the "structures became instruments for me to watch and learn about my relationship to this place."

That Singer is concerned with the different qualities of light and materials specific to individual sites is indicated by his deliberate decision to work in Vermont and Long Island, two very different locations. This concern is manifested also in the variations he has introduced into pieces executed in a number of other places. He responded to both the materials and climates of each area. Thus in the beaver bogs of Marlboro or in Saratoga Springs, New York (where he executed *Ritual Balance Series* [cat. no. 11] during July 1973 as his first commission for a public site), Singer worked with indigenous materials such as hemlock. The massive configurations of these pieces are appropriate to the rugged terrains and extreme climatic conditions prevalent there. For *Balance Ritual Series* (cat. no. 8), executed in Coral Gables, Florida, in the winter of 1972-73, he used bamboo, which he located growing on private property. The Florida sequence is similar to the pieces conceived for the saltwater marshes, as the bamboo is more supple than hemlock; both the materials and the climate that supports them occasioned a more fragile, attenuated linearity than that dictated by northern materials and locations. The bamboo and reed works are like drawings in the landscape and resulted in a rather complex piece, *Marsh Ritual Series* (cat. no. 9), which he produced in October of 1973 for Heckscher State Park on Long Island. *Marsh Ritual Series* is comprised of fourteen units of phragmites and bamboo scattered across an approximately fifty-acre saltwater marsh. The elements were barely visible in the generous expanse of the landscape, but the spectator slowly began to discern the individual parts and then to perceive the whole, and the work was ultimately and cumulatively impressive. Although the piece was destroyed by a storm shortly after completion, it was important for Singer: working on it he was more involved with learning about nature's processes than with creating a finite piece for a temporal situation. Equally significant, it gave rise to *Ritual Series 12/21/73* (cat. no. 10), the first of an impressive body of drawings.

Singer's drawings, like his sculptures, evoke both nature and ritual. The early drawings, especially *Ritual Series, 12/21/73* and the others that directly followed the *Marsh Ritual Series*, are, like the sculptures, spare in their configurations; they capture the essential delicacy of the marsh reeds, the linear grace and fluidity of bamboo and the feeling of the light, air and space of the sites that inspired both bodies of work. In the drawings, as in his sculptures, Singer refers to actual passages in the landscape — to a stand of trees, a pond, the saltwater marshes — as well as to more intangible, ephemeral phenomena — haze, mist, smoke, rain, eddies, rushing water, tides — and to the seasons themselves. He also occasionally alludes to the process of working — a motif, for example, anchors a series of images to the page at the same time it evokes an axe shape — but his vocabulary of forms springs from his feelings about nature rather than from a need to describe it. In this respect, his images recall those of Arshile Gorky whose landscape drawings reveal the mystery and magic, the poetry of the natural world. As Gorky began to "look into the grass," to observe in minute detail the forms of flowers, leaves, insects, to watch the wind as it ruffled the tall grasses, to feel the heat, the sun, the shadows, so Singer has experienced the elements of nature. Like Gorky, who elicited from nature a new vocabulary of forms, Singer is shaping his own very personal body of images.

The two artists share a passion for revealing the underlying forces and elemental forms of nature. Gorky's imagery, however, is Surrealist-inspired; his explorations of nature and inner states of existence are laden with Freudian symbolism and erotic content. Singer's perceptions of nature evolve from within himself and are given form through reference to Oriental culture and primitive ritual.

Whereas Singer's sculptures are all large scale, his drawings may be relatively small (less than two feet wide or high), medium in size (approximately fifty by forty inches) or large extended horizontals or verticals (measuring forty-five by ninety-six inches in either direction). He works with charcoal combined with chalk, paper collage and gouache on paper. Although the drawings are fluid and appear to be spontaneous, they are in fact the result of prolonged deliberation and reworking. Indeed, the collage elements are made of drawings that have been ripped and cut apart and pasted together again. The charcoal, chalk and gouache provide line, shape and color, while the layer of collaged papers adds both a real three-dimensional element and an illusion of space. The vertical forms in the drawings, like those in the sculptures, evoke totemic images as well as actual passages in the landscape. In addition to vertical forms, Singer frequently uses elliptical or oval shapes in conjunction with an active calligraphy, which has a superficial resemblance to Abstract Expressionist handling. While the drawings are sweeping and gestural and may at first seem impetuous, they are unified by the same sure equilibrium that prevails in the sculpture. For Singer's sense of measure and order is as fundamental to his work as is his need to capture the pulse of nature, the sense of the fleeting moment.

During January and February of 1975 Singer worked on the *Glades Ritual Series 1975* (cat. no. 15), an installation in the Everglades National Park in Florida. The site was a vast, open glades area, which was under water from May through November but was dry enough to work in during the winter. Like parts of the Western Redwood forests or the bush in Australia, it is constantly beset by fire, which actually contributes to the ecological balance of the area. In fact, a brushfire had swept through the area shortly before Singer began to work there. The fire had left the grass charred and the limestone ground visible, alterations in the environment that ultimately were reflected in his work. In addition, water erosion caused sinkholes to appear in the limestone, and Singer used these holes to dictate where he placed his bamboo structure. The *Glades Ritual Series 1975* was the most successfully resolved of Singer's land-related works to that date, for it captures the ephemerality of nature and of its materials (phragmites, jute rope and bamboo) and stands in complete harmony with the landscape in which it exists. Here for the first time the artist sited his work in a particular direction. He oriented the piece on an east-west axis, with access from the west. As a result, the spectator's point of view and perception of light was controlled: when seen in the morning the work was backlit; by the end of day it was fully illuminated.

Singer observed the Everglades site during the summer before he worked on the *Glades Ritual Series 1975*. The landscape reflections he saw in the ponds created by the summer floods inspired him to seek a new situation for his outdoor sculpture. The result of this quest is the *Lily Pond Ritual*

Series 7/75 (cat. no. 18), an extended horizontal piece he built in Harriman State Park in New York in July 1975. Like *Balance XXIV* and *Centering Balance* (cat. nos. 1,3), both 1971, the *Lily Pond Ritual Series 7/75* is about span, balance, horizontality and place. Although it is approximately eighty-five-feet long, the construction seems modest in relation to the very large pond, the extravagant foliage that rims it and the equally extravagant shadows cast in the water. And like the *Marsh Ritual Series*, 1973, and the *Sangam Ritual Series 4/76*, 1976 (cat. nos, 9,19), it is so understated that it seems to merge with the landscape. Only after prolonged viewing is the spectator able to isolate the delicate tracery of the structure from its surroundings. Singer has remarked that the work of the mid- to late-1970s illuminates the environment for him and for the spectator, for the sculpture reveals itself as the result of our perception of the landscape.

Other equally successful works of the period are the *First Gate Ritual Series* of 1976 (cat. no. 21), an installation for the Nassau County Museum of Fine Art in Roslyn, New York, and a similar piece of the same title made for the *Documenta 6* of 1977. Both are two-part constructions that elaborate upon line, light and reflections. And probably because their park settings are more cultivated and their ponds more distinct in shape than Singer usually chooses, both seem more substantial and more independent than the earlier work. As Singer began to work in public locations, aware that his pieces would be seen for long periods of time, he became increasingly concerned with their durability and with access to them. This represented a substantial departure from his earlier attitude, wherein the human presence was not considered and the works were the basis for private experiences between artist and nature. In his use of oak and rock here, the artist is introducing materials that presage a new direction in his work. Yet the two-part pieces retain a characteristic sense of equilibrium that mediates between the shifting forces of the water as well as an equilibrium sustained by the thrusts and counterthrusts within the work. More important, the configurations of these two sculptures recall ancient Egyptian and Peruvian reed boats and thus pay homage to the culture that inspired both Heyerdahl and Singer himself.

Singer notes that stones and bricks were used exclusively to counterbalance the other elements in the works of the early 1970s. Later, in his first gallery piece, *Ritual Balance Series 12/75* of 1975 (cat. no. 17), for example, the stones are used both as foundation — as architectural elements — and as referents to the stones the beavers placed in their dam. The eroded, soft-edged bricks in the work suggest both architectural construction and the weathering process of nature. Singer elaborates on the increasingly complicated functions of his materials:

> *In the pieces between 1975 and 1980 I used stones as a foundation and as a structural element between the wooden beams (both curved and straight), helping to create the physical tension that held these wooden elements together. As these sculptures became more complex there was an ambiguity about whether the stone supported the wood or did the wood exist to support the stone. The interdependence of the two was physical — structural and visual.*

In later work such as *First Gate Ritual Series, 1980* (cat. no. 36), shown in Zürich and at the Ringling Museum in Sarasota:

> *[The rocks] become a presence apart from their structural function. The ambiguity between wood and stone lessens. The wood clearly supports certain stones. I sense these stones as symbols containing references to mountain, river, cloud, natural elements.*

> *I take long walks to look for stones that come from walls, fields and streams. Once I have the stones I place them in the studio where I spend a long time determining which edges should be cut. I categorize the stones visually — vertical, horizontal, diagonal, round, sharp, weathered by the air, time honored.*

Singer's outdoor sculpture has progressed through three distinct phases. During the first, which corresponded to the three years he worked in the beaver bogs in Marlboro and the Long Island saltwater marshes, he was preoccupied with working in, learning from and adapting to nature. During the second he made pieces that helped him see nature and define place. By 1979 he was creating sculpture that was interdependent with place. Intimations of this interdependence are already present in *Bog Ritual Series 6/78*, a piece executed in a beaver bog in 1978 in Marlboro. However this harmony was not fully realized until *First Gate Ritual Series 4/79*, made for DeWeese Park in Dayton (cat. no. 28). Singer believes that the site pushed him further in this direction than he had gone before. It challenged him to integrate the experience of the beaver bogs with that of the saltwater marshes. With this piece he introduced phragmites and bamboo into a rugged terrain reminiscent of the Vermont landscape. Singer's exploitation of light, shadow, his sensitivity towards density, mass, volume, line, texture and color, both in the environment and in the forms he created made this his most successful outdoor work to that date.

Concurrent with his development of outdoor sculpture, Singer concerned himself with indoor pieces. In two transitional pieces executed in his New York studio in 1974-75 (cat. nos. 13,14), he attempted to readjust to the unchanging confines of the studio or gallery without sacrificing the meaning of the sculpture of the four preceding years.

In 1975 he accomplished this readjustment, when he created the above-mentioned *Ritual Balance Series* for the Greene Street space of the Sperone Westwater Fischer Gallery. This work, *Sangam Ritual Series 9/77* of 1977 and *First Gate Ritual Series 10/78* of 1978 (cat. nos. 26,27) were conceived for specific indoor sites. *Ritual Balance Series* was carefully placed and lit, with meticulous consideration of the specifics of the Greene Street gallery space. It was Singer's objective to allow the spectator to navigate the entire circumference of the piece, which measures twelve by sixteen by sixteen feet, and thus be able to perceive the whole as well as the individual parts. Here Singer retained a continuity with his previous work, in particular in the emphasis on equilibrium. But he brought to the piece a new sense of place by acknowledging the interior site in the articulation of

the wall and floor planes and in the leanness of the construction, which was entirely appropriate to the spareness of the gallery. The interplay of line and curve, of color and textures, the natural elements—wood, phragmites, bamboo and stones—and the configuration of the whole are gracefully accommodated to the space. However, the piece was not a mere reflection of the interior, but was invested with a powerful spiritual aura, an independent magical presence.

By the summer of 1979, consideration of mass and gravity began to replace the concern with the more temporal qualities of air, light, water in Singer's work. He remarks:

At this time, and now, I notice the stone walls, stone outcroppings and ledge. I'm impressed with stories about how the settlers of this region struggled to clear the land of the stones only to find more forced to the surface each year by winter frost. I observe the geology underlying nature's structures, the layering of the foundations of the earth, the deeper structures creating the contours.

In keeping with the new emphasis on the permanent and enduring, stone began to replace marsh reeds and bamboo, and the foundations of the sculpture assumed a more significant role. First in the outdoor sculpture, later in the indoor, stone — ancient, full of historical and mythological associations — became the symbol of the eternal.

The ambiguity in the relationship between wood and stone that had existed in the earlier work gradually was eradicated, as the wood was shown clearly to support certain stones. In works of the early 1980s Singer constructed wooden platforms whose central function was to contain and emphasize stones. The stones begin to take on a significance beyond their structural meaning: they become symbols of natural elements—rocks, streams, cloud formations. In *Ritual Series 80/81*, 1980-81 (cat. no. 40), the rocks have been selected and altered to enhance symbolic allusions. The most recent compositions are made entirely of stone; they are denser and more complex than the previous work, yet retain the sense of balance and completeness of their precursors.

Recently the drawings, as well as the sculptures, have become denser, more compact. There are fewer references to illusionistic landscape depth, and energy seems to flow closer to the picture plane. The earlier drawings are linear and open; space flows freely around forms and there is a sense of shallow three-dimensional space. Horizontal and vertical forms seem ordered into an allover pattern by an implied grid. Now, however, in the drawings, as in the sculptures, there is a sense of enclosure. Forms, which tend to be self-contained and isolated, are beginning to assume a ritualistic meaning, as Singer's vocabulary takes on a new metaphorical quality.

Apparent in the early as well as the recent drawings is Singer's painterly sensibility, which reveals itself in his virtuousity, his consummate ability to manipulate line, plane, straight edge and curve, to control thick and thin contour, gesture and color. Whereas stateliness prevails in the sculpture, and the drawings are marked by immediacy and intimacy, the works in the two mediums are linked by their characteristic thoughtfulness. More importantly they are unified by the absolute consistency

of Singer's commitment to interpreting the majestic, immutable forms of nature and its elemental, underlying forces.

Singer has recently favored slate and granite. The inner core of *First Gate Ritual Series 1982* (cat. no. 47) is slate and the outer structure and "natural" rocks or fieldstones are granite. The *Cloud Hands Ritual Series* and *Seven Moon Ritual Series*, both 1983-84 (cover [foreground], cat. no. 48), are comprised entirely of granite: *Cloud Hands* is gray and white stone from Vermont; the exterior of *Seven Moon* is a dark, almost charcoal, gray rock from Pennsylvania called "Mist"; the inner structure is a light gray granite from Vermont. Slate results when layers of silt containing vegetation and organisms are subjected to heat and pressure. The fossil materials are obliterated during the process, but leave traces in the form of streaks and imperfections. Granite is an igneous rock, formed from molten matter deep within the earth; its minerals crystallize as the rock cools. Singer has explained why these rocks appeal to him. He says he chooses slate for its innate layering, "because of the process that it has gone through, it seems like a rock that is more 'alive.'" However, for Singer, "granite is the most enduring and stable stone. It is this quiet, serene sense that attracts me."

Harmony and order, simplicity and balance inform the granite and slate sculptures, as they do his previous work. Even in as early a piece as *Balance XXIV*, Spring 1971, there is a pervasive calm, a simplicity and equilibrium that is at odds with both the characteristics of the sculpture of his peers and with the nature of the city. Central to all his work too has been a powerful sense of ritual and myth, which serves to unify his allusions to man and nature. That Singer's objective is to capture a feeling of the rituals of nature is indicated in his discussion of the *Glades Ritual Series*:

> *I built a structure using materials indigenous to the area. It was to become the symbol for a ritual. The ritual took place throughout the day at different moments — once when the structure seemed to catch the low clouds as they passed through it; once when the light silhouetted the piece against the pineland forest illuminating it intensely for a moment; and again, when the full moon on the eastern horizon coincided with the setting sun, causing the piece to shine with the colors of the reflected light. The piece provided the apparatus for the rituals of any given day to take place.*[4]

Here the artist touches upon a concept that underlies much of his work—that the site has magical, ritualistic significance. This idea is reflected in his titles — not only *Glades Ritual Series* but also *Sangam Ritual Series* of 1976, which refers to a site in India where a shrine marks the junction of rivers. Beginning with works such as *First Gate Ritual Series* of 1979 and 1980 (see cat. nos. 32,38), Singer saw mythic connotations in the landscape; later, in indoor sculptures of 1982 such as *Cloud Hands Ritual Series 1982*, *Ritual Series 7/82* and *Ritual Series 1982* (cat. nos. 42,43,45) Singer continued to evoke the same sense of ritual in nature. In the new slate and granite pieces, Singer has extended the original concepts without losing sight of nature: now the magic emanates from the self-contained work itself, and does not depend on the environmental context.

Singer's newest structures resonate with a spiritual aura usually associated with religious art. This aspect of his work calls to mind oriental precedents — as well as Barnett Newman's *Stations of the Cross*, 1966, abstract paintings that express deep spiritual meaning and mythic content. Indeed, both sources have had a profound impact on his imagination. In much of the work executed since 1980, there is a feeling of self-containment. These are low structures whose "walls" act, not as barriers as they do in Western architecture, but as gates that lead into the interior, evoking fences and gates of Shinto shrines. The walls and the platforms that connect them introduce us into a sequence of measured spaces. These magical enclosures evoke ritualistic associations and encompass a universe that is part nature, part myth. As Joseph Campbell has said, rituals are organizations of mythological symbols, and by participating in the drama of the rites one is brought directly in touch with these symbols. "The function of ritual...is to give form to human life."[5] Through his arresting, evocative sculpture and drawings Michael Singer gives significance and form to both life and art.

FOOTNOTES

1. Diane Waldman, *Ten Young Artists: Theodoron Awards*, exh. cat., The Solomon R. Guggenheim Museum, New York, 1971, n.p.

2. Unpublished notes by the artist, December 1983. All succeeding remarks by the artist are from the same source, unless otherwise noted.

3. Statement in Michael Auping, *Common Ground: Five Artists in the Florida Landscape*, exh. cat., The John and Mable Ringling Museum of Art, Sarasota, Florida, 1982, p. 52.

4. Ibid., p. 53.

5. Joseph Campbell, *Myths to Live By*, New York, 1972, p. 43.

1. *Balance XXIV.* Spring 1971
 Wood and lead fire-bricks, 10 × 216 × 288″
 Collection of the artist

Installation view,
Ten Young Artists: Theodoron Awards, Solomon R.
Guggenheim Museum, New York, 1971

2. left: *Limit Balance III.* 1971 (destroyed)
 Steel I beams, 336 × 180 × 36″

 right: *Unit Balance I.* 1971
 Wood, 48 × 108 × 60″
 Collection of the artist

3. *Centering Balance.* 1971
 Steel beams and bricks, 120″ long
 Collection Solomon R. Guggenheim Museum,
 New York

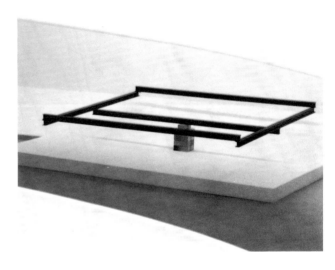

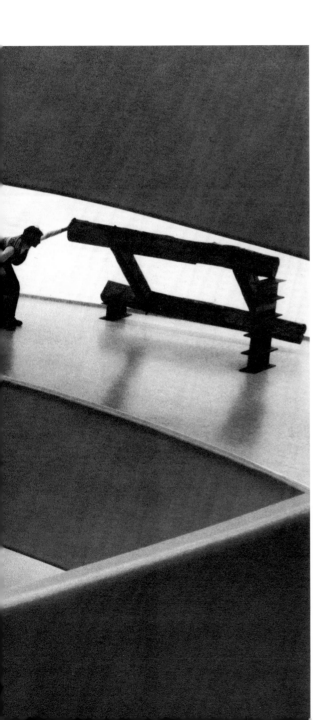

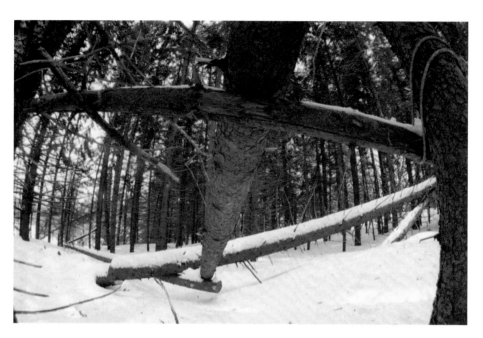

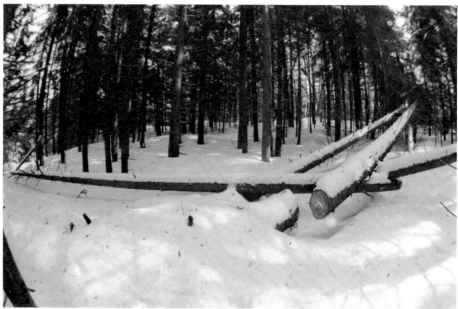

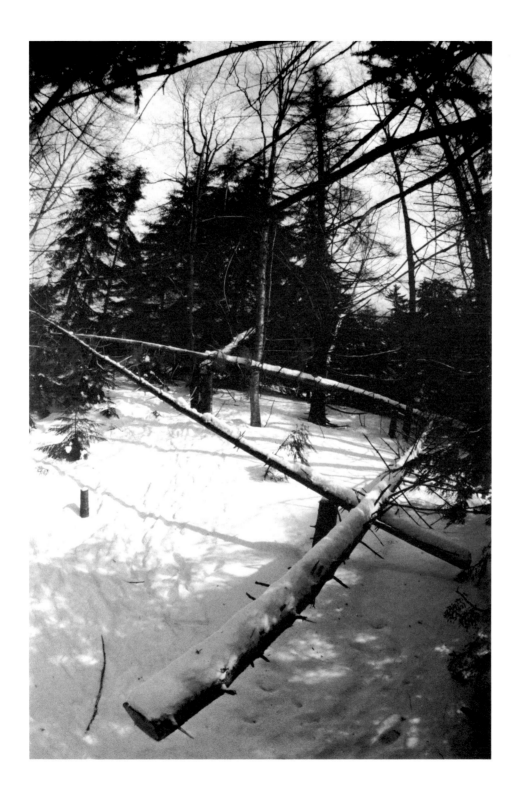

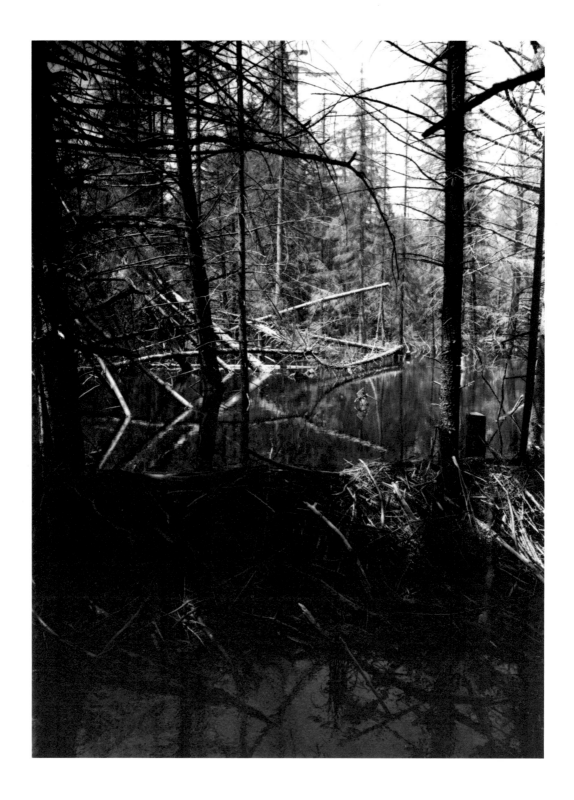

6. *Situation Balance Series Beaver Bog.* 1971-73
 Hemlock trees and jute rope
 Marlboro, Vermont

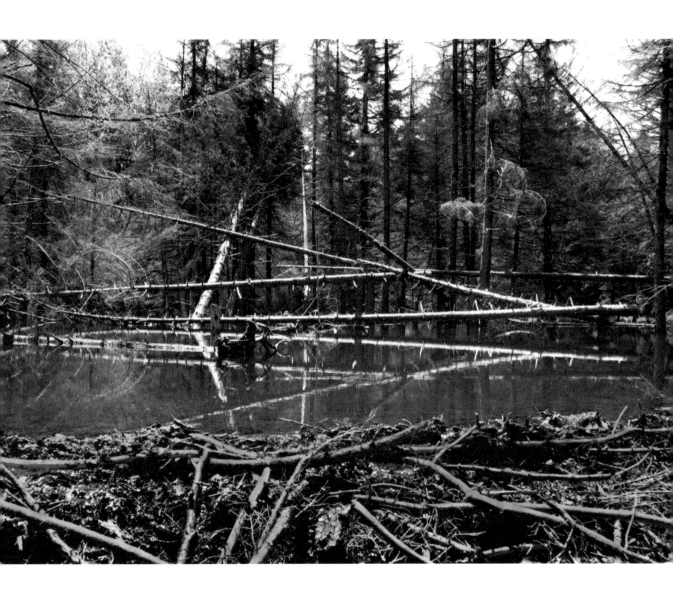

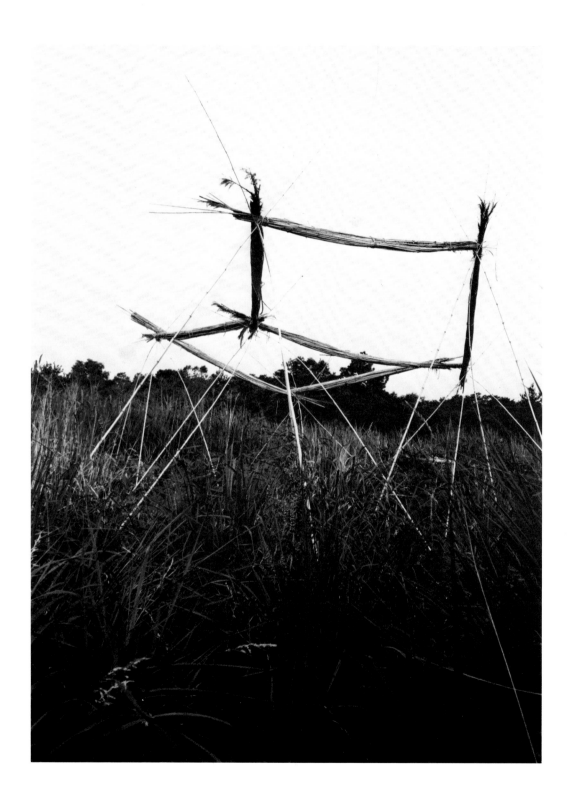

7. *Ritual Balance Series Pelham Bay Park.*
 June 1972
 Phragmites, bamboo and jute rope
 Supported by a grant from CAPS
 Bronx, New York

8. *Balance Ritual Series.* Winter 1972-73
 Bamboo, jute rope and rocks
 Coral Gables, Florida

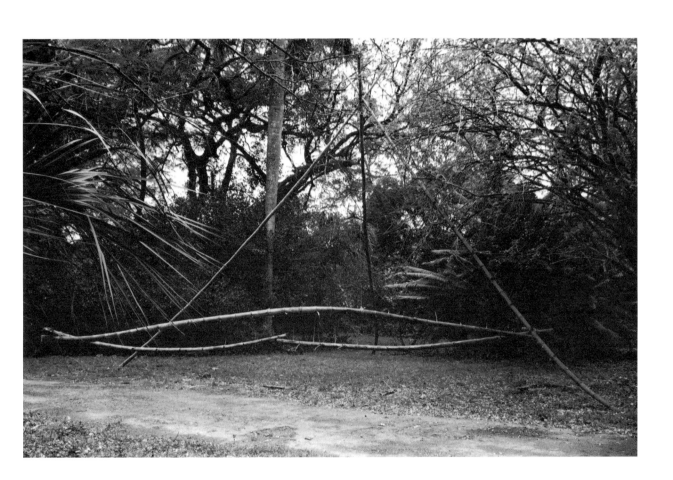

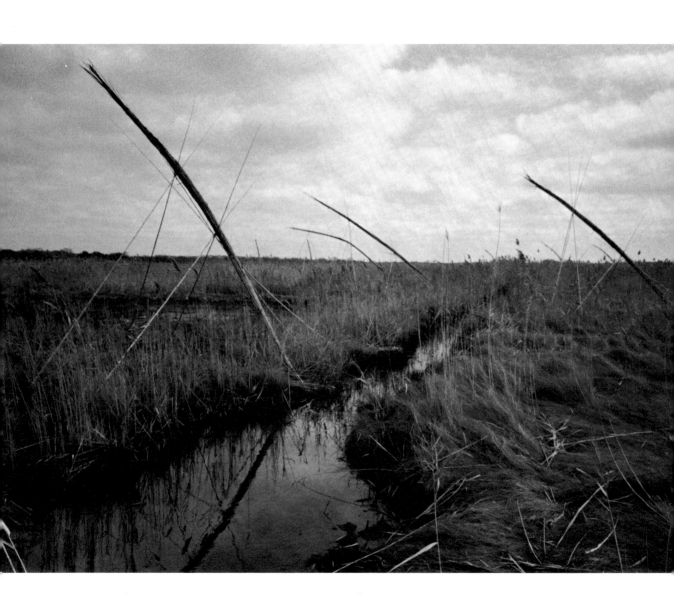

9. *Marsh Ritual Series*. October 1973
 Phragmites, bamboo and jute rope
 Supported by a grant from CAPS
 Heckscher State Park, East Islip, Long Island

10. *Ritual Series 12/21/73*. 1973
 Paper collage, charcoal and chalk on paper,
 48 × 48″
 Collection of the artist

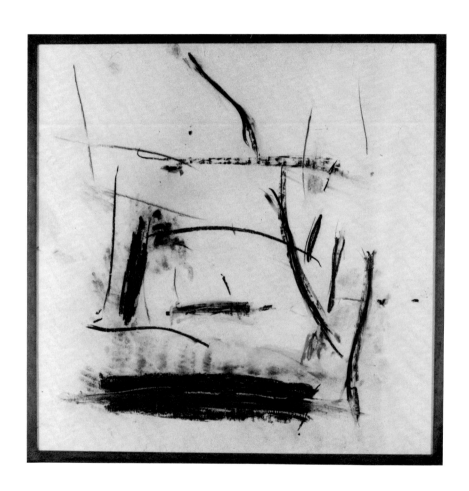

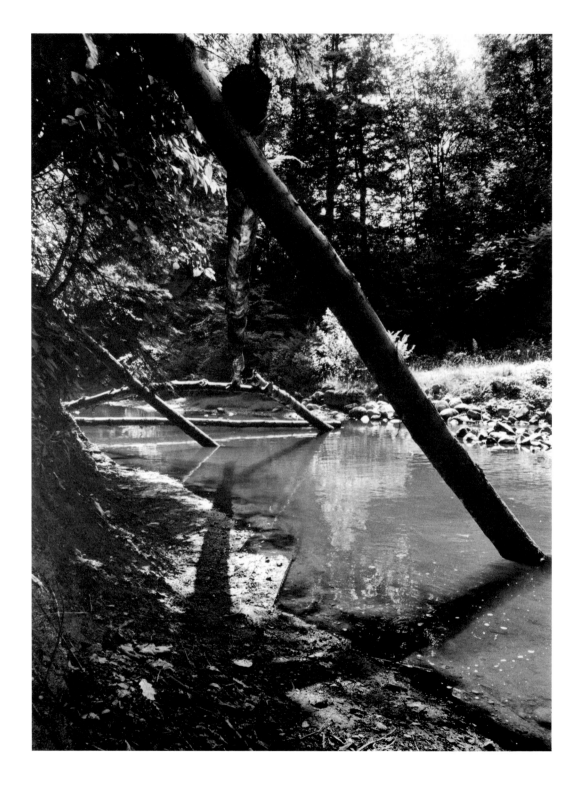

11. *Ritual Balance Series.* July 1973
 Hemlock trees
 Supported by a grant from CAPS
 Saratoga Performing Arts Center, Saratoga Springs,
 New York

12. *Ritual Series 1974.* 1974
 Paper collage, charcoal and chalk on paper,
 51 × 43"
 Collection of the artist

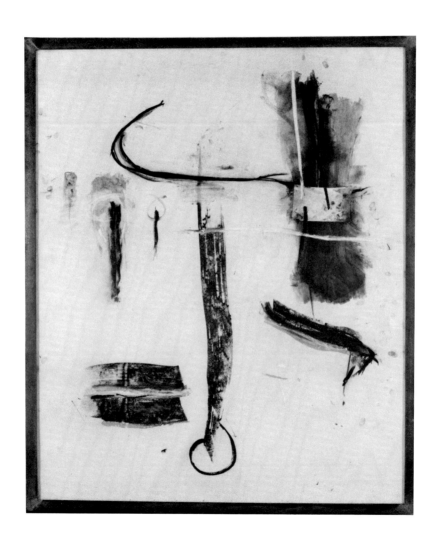

13. *Ritual Balance Series 1974.* 1974 (destroyed)
Bamboo, phragmites and jute rope
Installation view, Ludlow Street studio

14. *Ritual Balance Series 1975.* Fall 1975 (destroyed)
Bamboo, phragmites and jute rope
Installation view, Ludlow Street studio

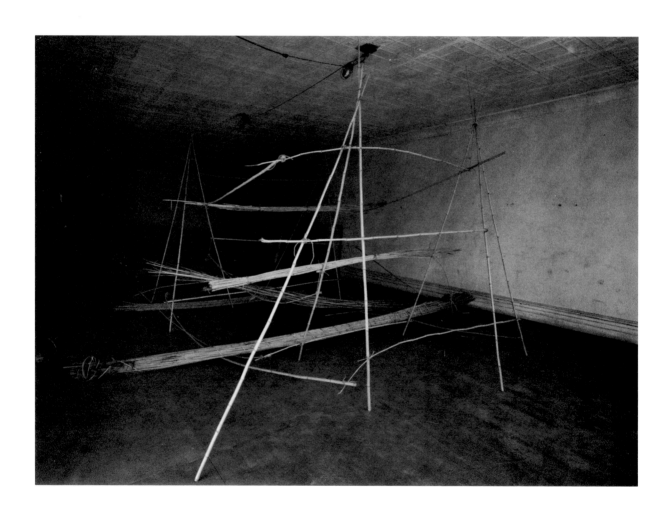

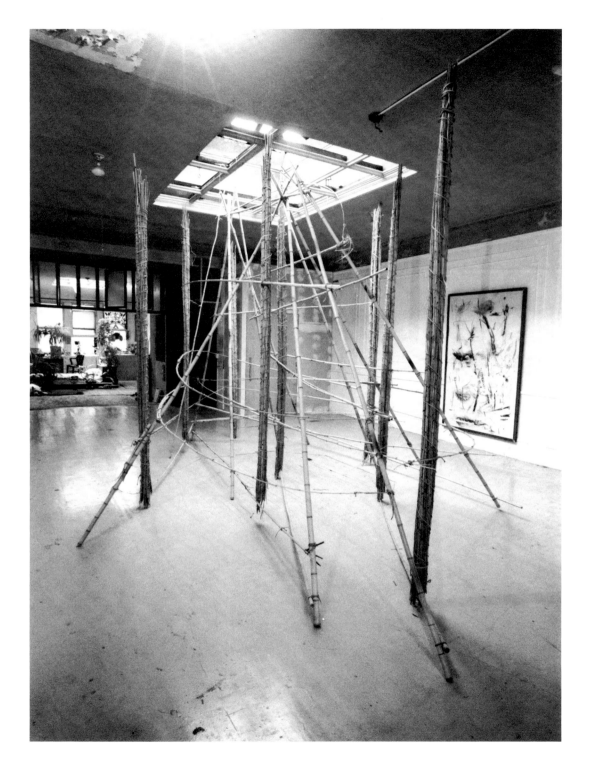

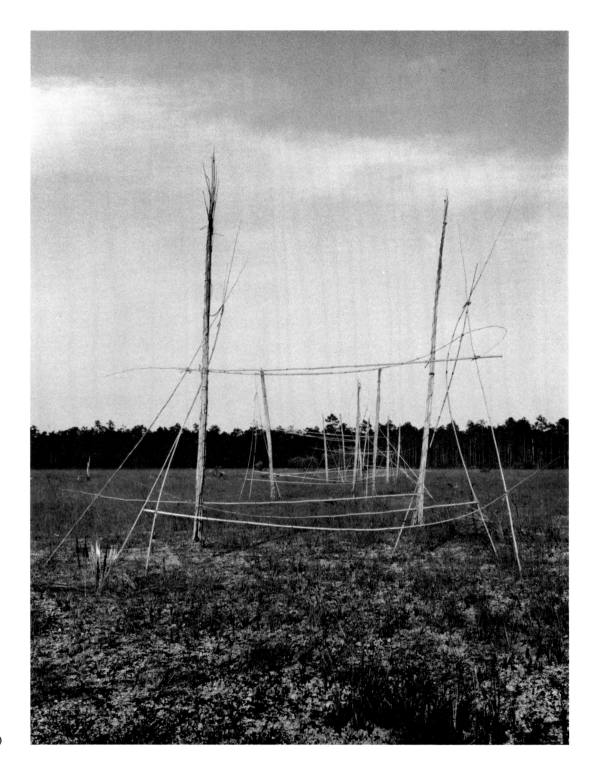

15. *Glades Ritual Series 1975.* 1975
 Phragmites, jute rope and bamboo
 Everglades National Park, Homestead, Florida

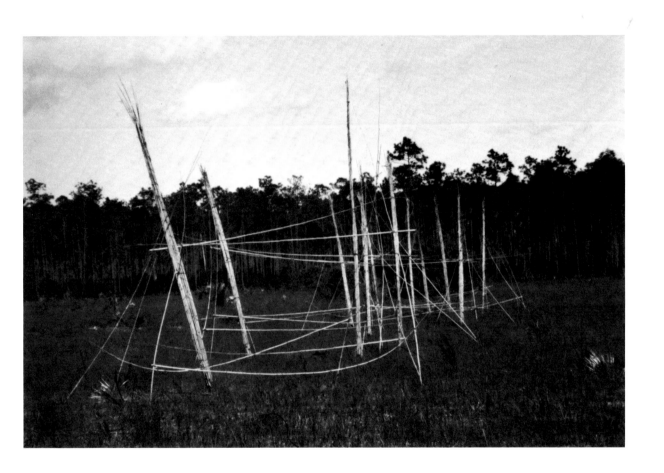

16. *Ritual Series 11/7/74*. 1974
 Paper collage, charcoal and chalk on paper,
 51 × 43″
 Collection of the artist

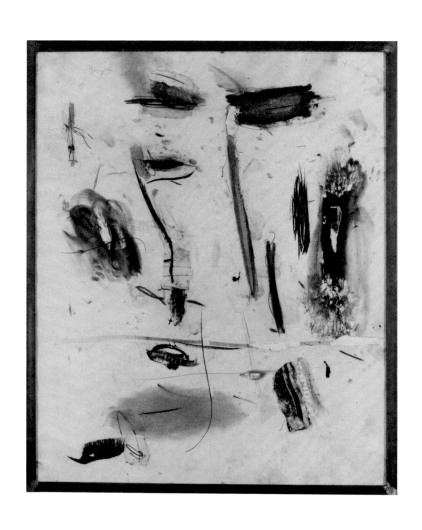

17. *Ritual Balance Series 12/75.* 1975
 Phragmites, rocks, bricks and wood,
 144 × 192 × 192″
 Collection Australian National Gallery, Canberra

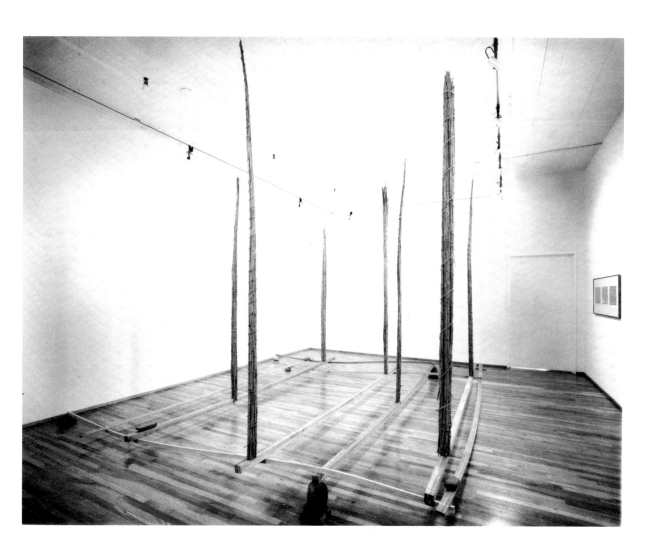

18. *Lily Pond Ritual Series 7/75*. July 1975
 Bamboo and jute rope
 Harriman State Park, Harriman, New York,
 Courtesy of Palisades Interstate Park Commission

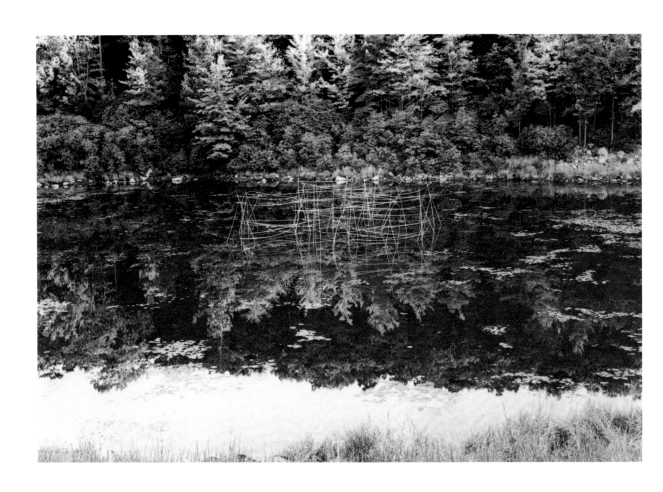

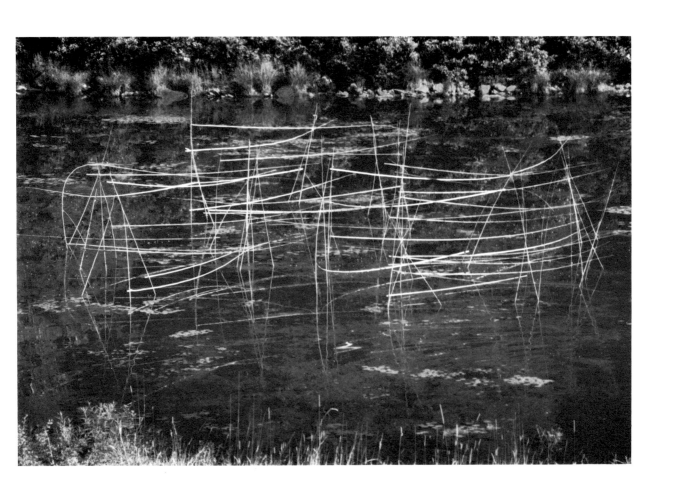

19. *Sangam Ritual Series 4/76.* 1976
 Bamboo, phragmites and jute rope
 Chesapeake Bay Center for Environmental
 Studies, Edgewater, Maryland

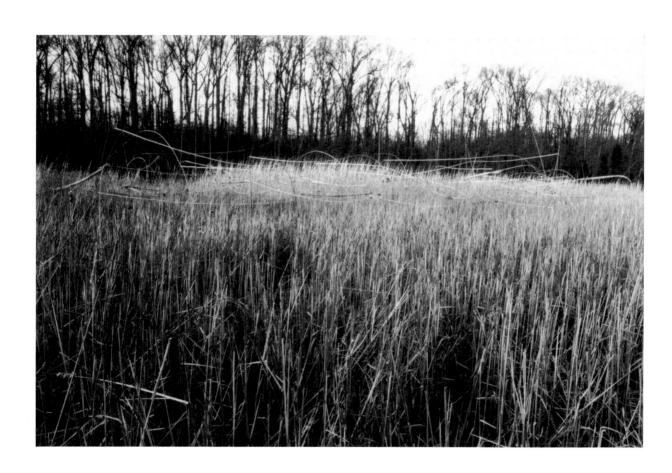

20. *Ritual Series 4/3/76*. 1976
 Paper collage, charcoal and chalk on paper,
 42 × 82"
 Collection Neuberger Museum, State University of
 New York at Purchase

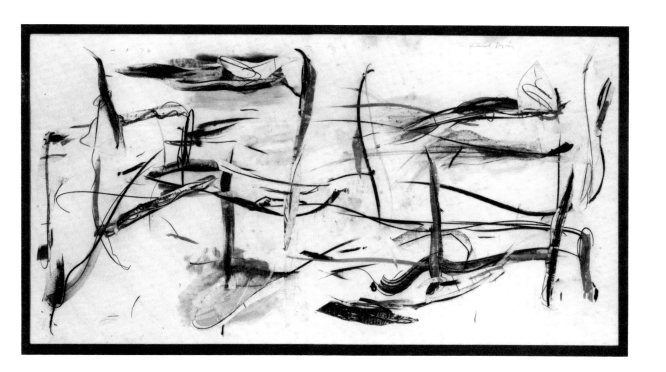

21. *First Gate Ritual Series.* 1976
Oak and rocks
Nassau County Museum of Fine Art, Roslyn,
New York

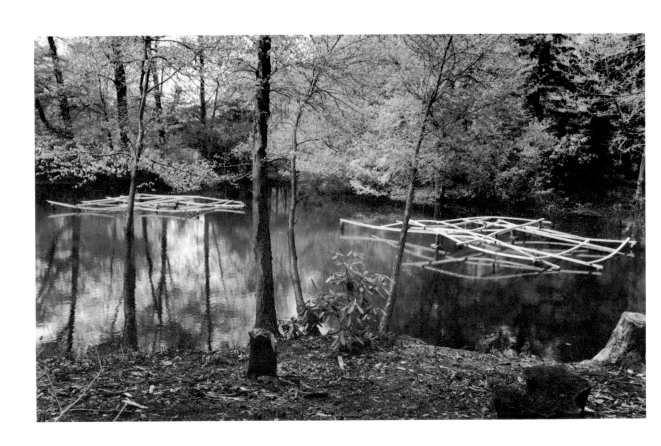

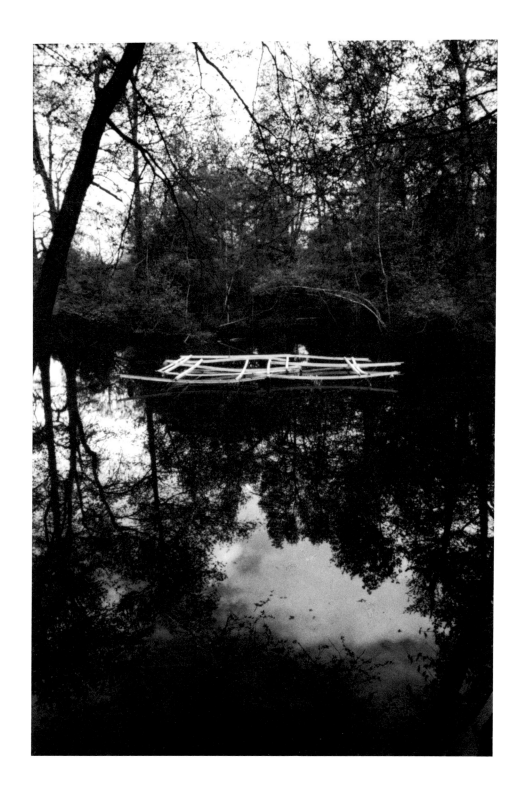

22. foreground: *First Gate Ritual Series Part II.* 1978
 Wood, stones and phragmites, 108 × 156 × 180″
 Collection of the artist
 background: cat. no. 26
 Installation view, Haydenville, Massachusetts,
 studio

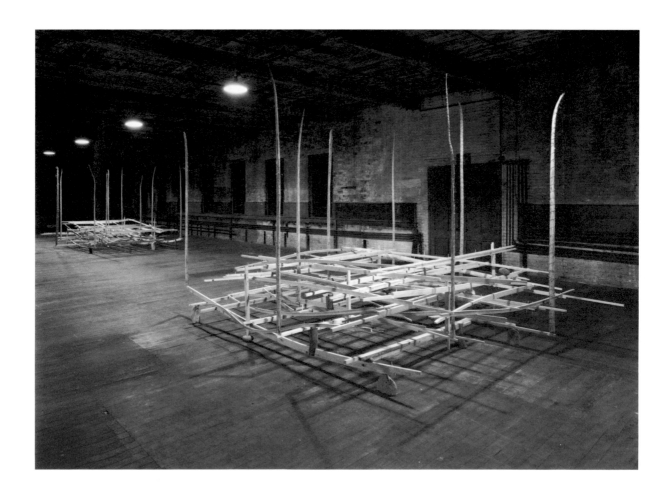

23. *First Gate Ritual Series 1/30/76.* 1976
 Paper collage, charcoal and chalk on paper,
 45 × 84½"
 Collection Paine Webber Inc., New York

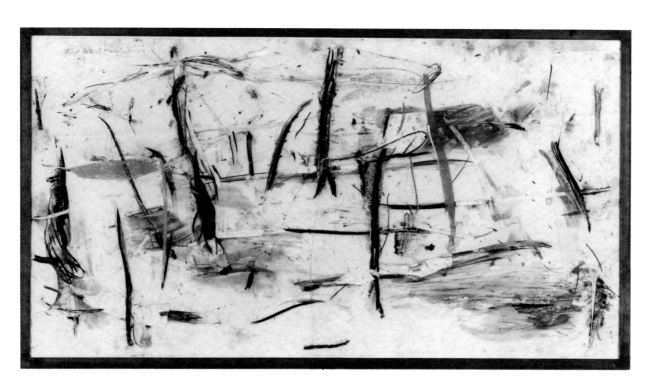

24. *Ritual Study 5/31/76.* 1976
 Paper collage, charcoal and chalk on paper,
 21 × 47¼″
 Collection Sidney Singer

25. *Sangam Study 10/11/76.* 1976
 Paper collage, charcoal and chalk on paper,
 21 × 47¼″
 Collection Mr. and Mrs. Judd Weisberg

*26. *Sangam Ritual Series 9/77.* 1977 (detail)
 Pine, rocks, phragmites and jute rope,
 168 × 456 × 216″
 Collection Solomon R. Guggenheim Museum,
 New York, Gift, Sidney Singer, 1983

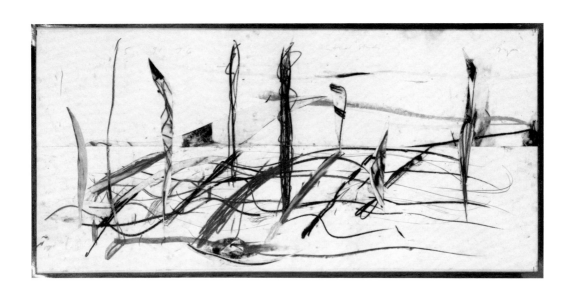

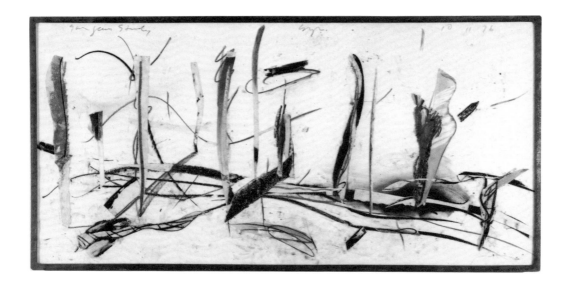

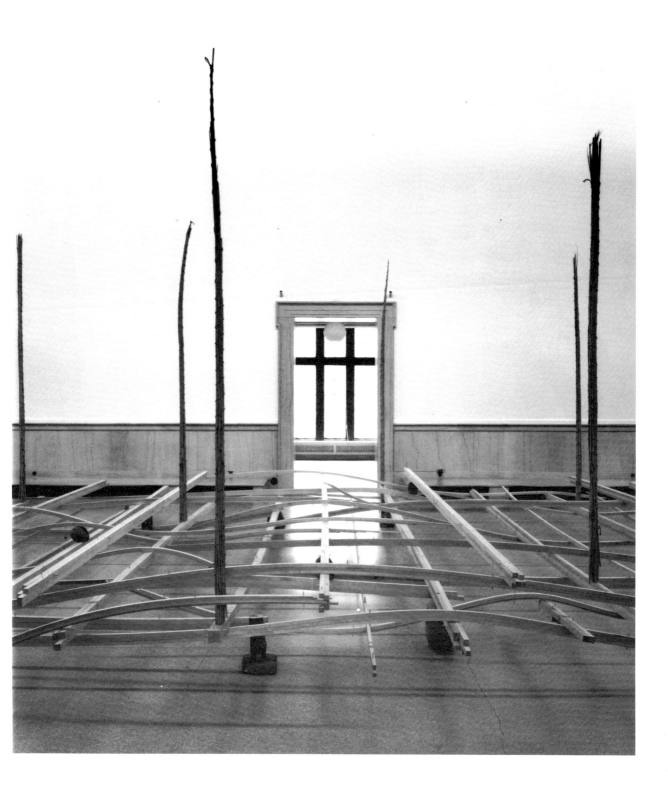

27. *First Gate Ritual Series 10/78.* 1978
 Wood, stones and phragmites, 108 × 156 × 180″
 Collection Fort Worth Art Museum, Texas

28. *First Gate Ritual Series 4/79.* 1979
 Bamboo and phragmites
 DeWeese Park, Dayton, City Beautiful Council,
 Dayton, Ohio

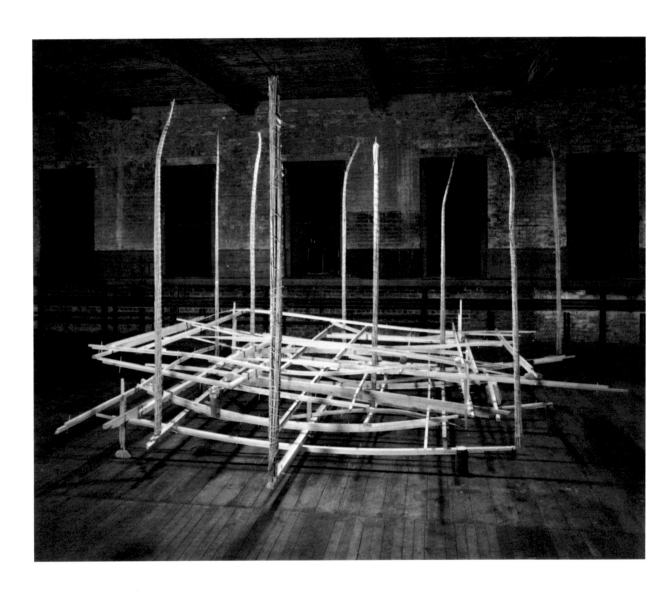

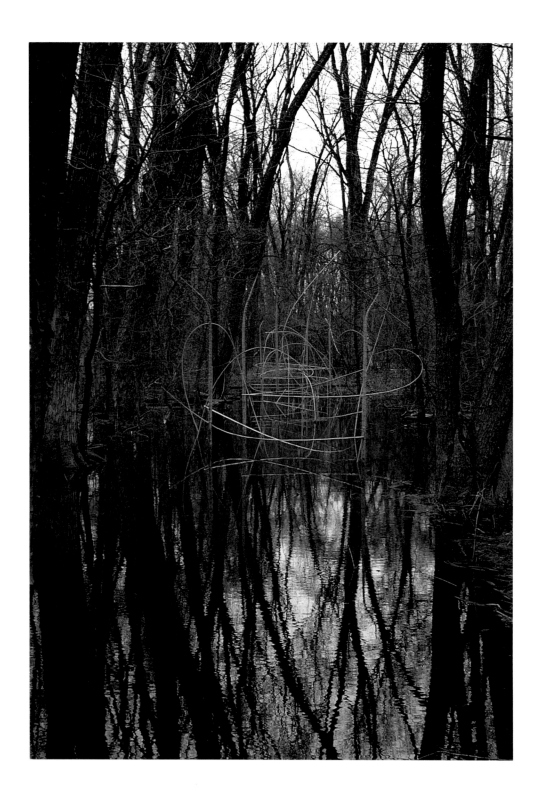

29. *Ritual Series 6/12/76.* 1976
 Paper collage, charcoal and chalk on paper,
 47¾ × 46⅝"
 Collection Barbara and Donald Jonas, New York

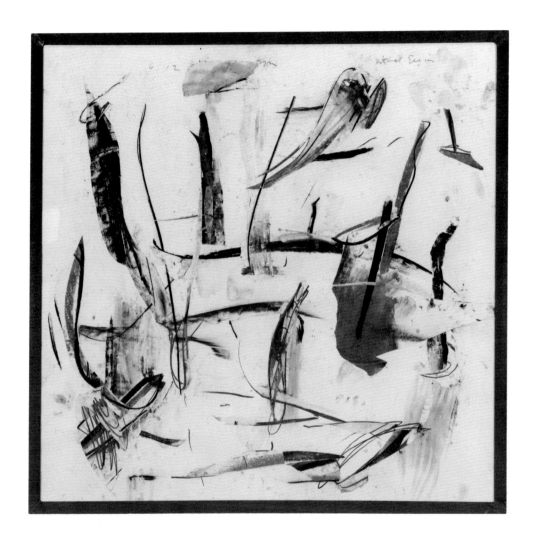

30. *Ritual Series 11/9/78.* 1978
 Paper collage, charcoal and chalk on paper,
 43⅝ × 31⅝″
 Collection of the artist

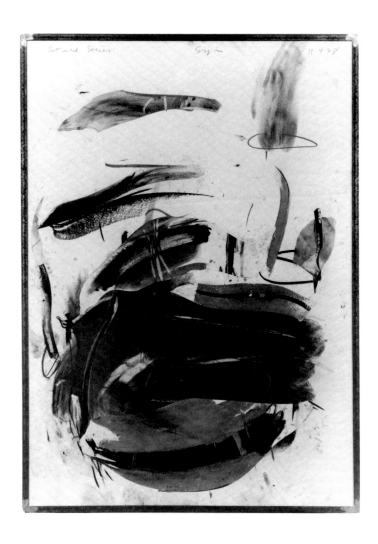

31. *Ritual Series 5/79.* 1979
 Spruce branches and jute rope
 Wilmington, Vermont

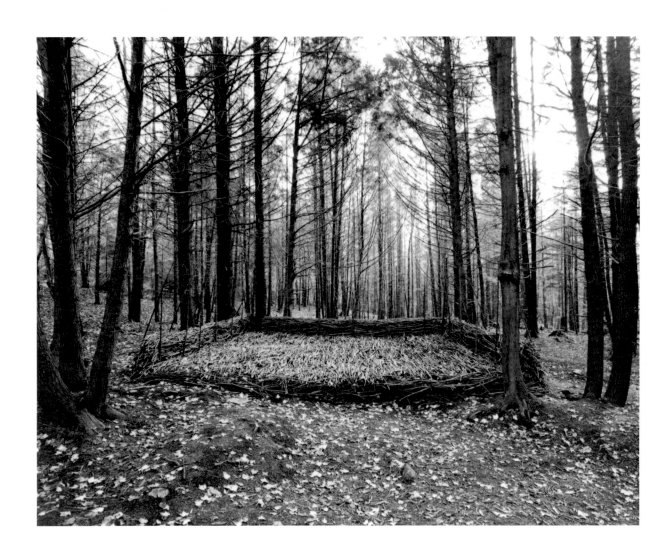

32. *First Gate Ritual Series 7/79.* 1979
Oak, phragmites, rocks, jute rope and spruce
branches
Wilmington, Vermont

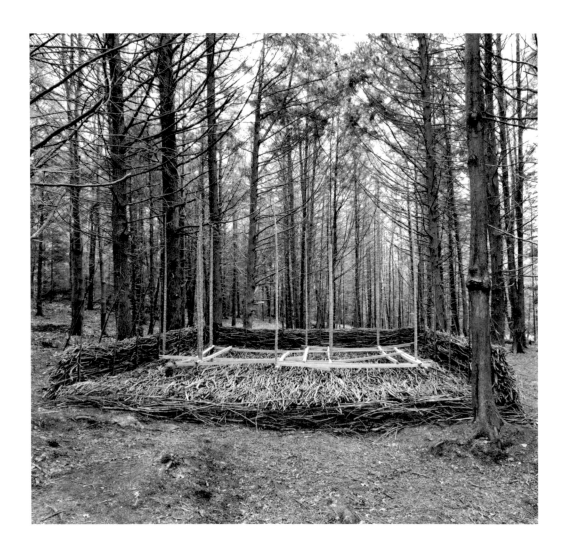

33. *Ritual Series 1/2/79.* 1979
 Paper collage, charcoal and chalk on paper,
 59¼ × 43⅜″
 Collection Yale University Art Gallery, New Haven,
 Gift of Mr. and Mrs. Robert F. Shapiro, BA 1950,
 in honor of Robert F. Shapiro's 25th class reunion

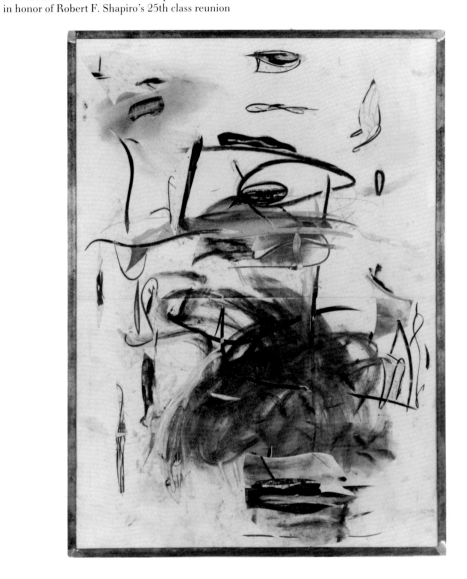

34. *Seven Moon Ritual Series 3/21/79.* 1979
 Paper collage, charcoal and chalk on paper,
 57½ × 41″
 Collection Solomon R. Guggenheim Museum,
 New York, Anonymous gift, 1983

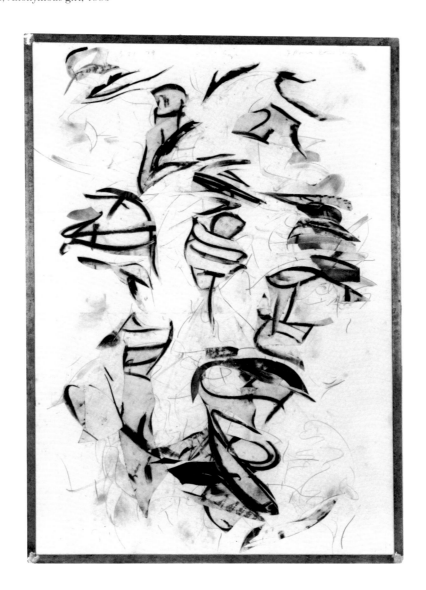

35. *First Gate Ritual Series 2/80.* 1980
Oak and rocks, 53 × 144 × 156″
Courtesy Sperone Westwater, New York

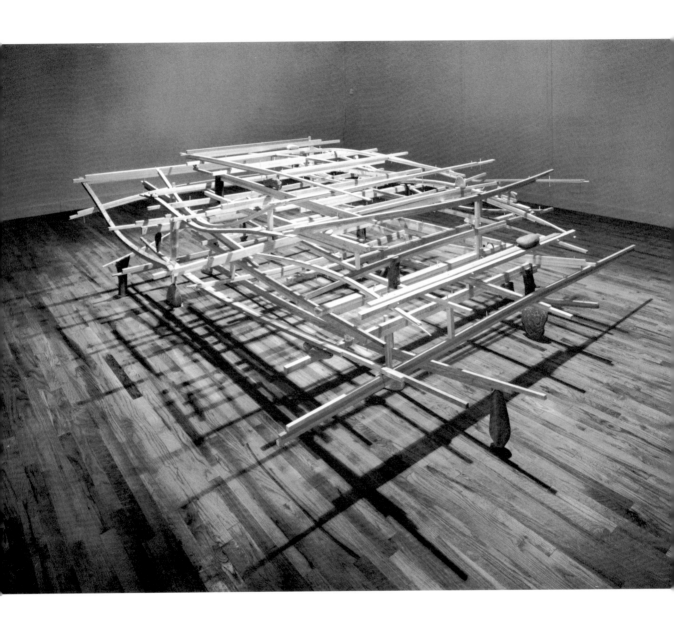

36. *First Gate Ritual Series 1980.* 1980
 Pine and rocks, 60 × 114 × 163″
 Courtesy Sperone Westwater, New York

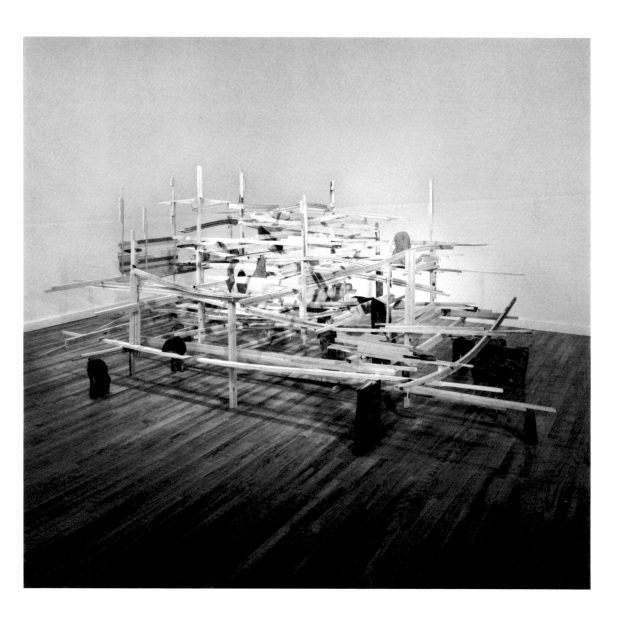

37. *Ritual Series 8/19/81.* 1981
 Paper collage, charcoal and chalk on paper,
 50½ × 38½"
 Private Collection

38. *First Gate Ritual Series 5/80.* 1980
 Pine, rocks and spruce branches
 Riehen, Switzerland

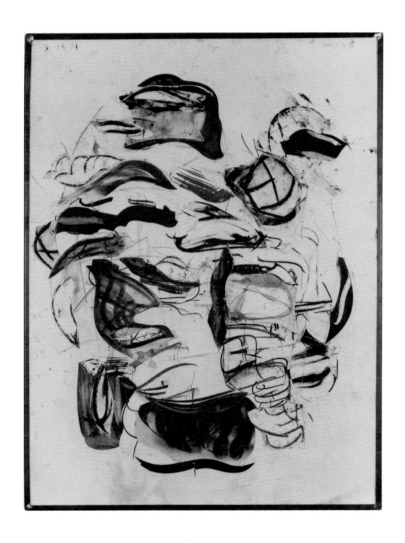

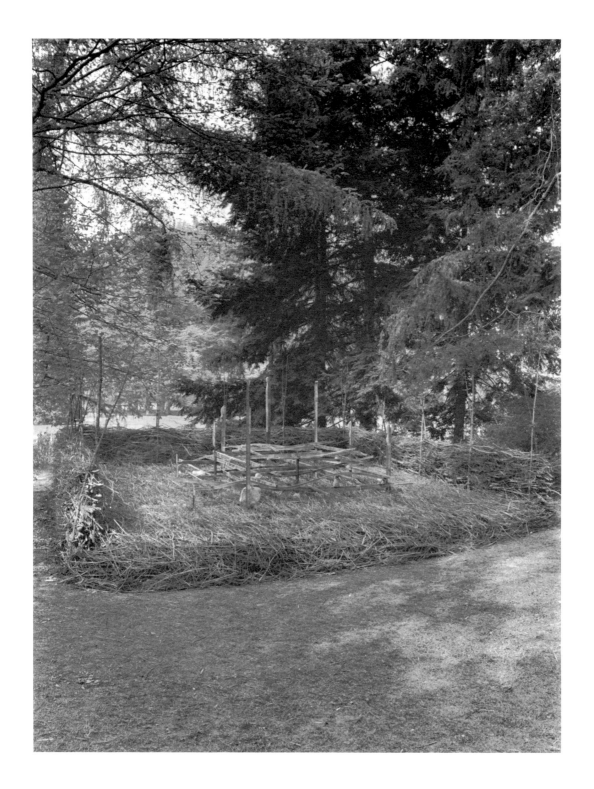

39. *Seven Moon Ritual Series 7/25/80.* 1980
 Paper collage, charcoal and chalk on paper,
 39¼ × 84¼"
 Collection Diane and Steven Jacobson, New York

*40. *Ritual Series 80/81.* 1980-81
 Wood and rocks, 58½ × 207 × 217"
 Collection Solomon R. Guggenheim Museum,
 New York, purchased with the aid of funds from the
 National Endowment for the Arts in Washington,
 D.C., a Federal Agency; matching funds contrib-
 uted by Barbara and Donald Jonas and Diane and
 Steven Jacobson

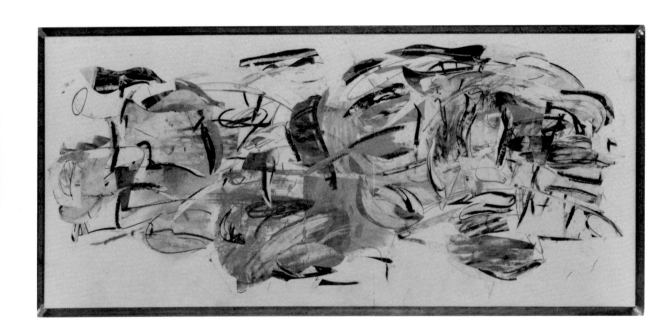

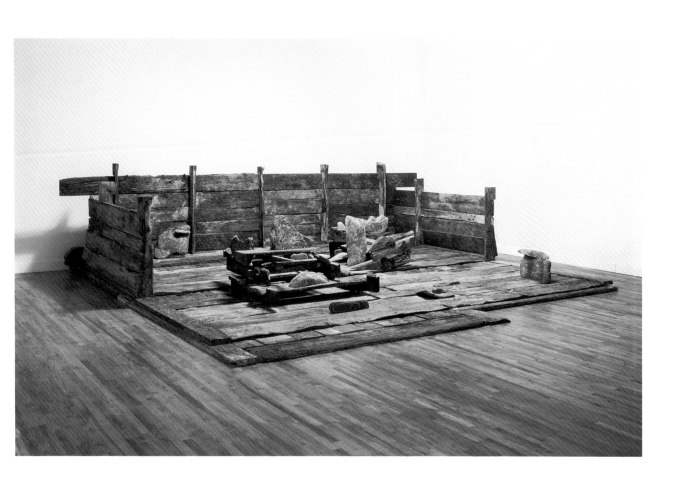

41. *Cloud Hands Ritual Series 80/81.* 1980-81
Pine, ash and rocks, 57 × 171½ × 201″
Collection Louisiana Museum of Modern Art,
Humlebaek, Denmark

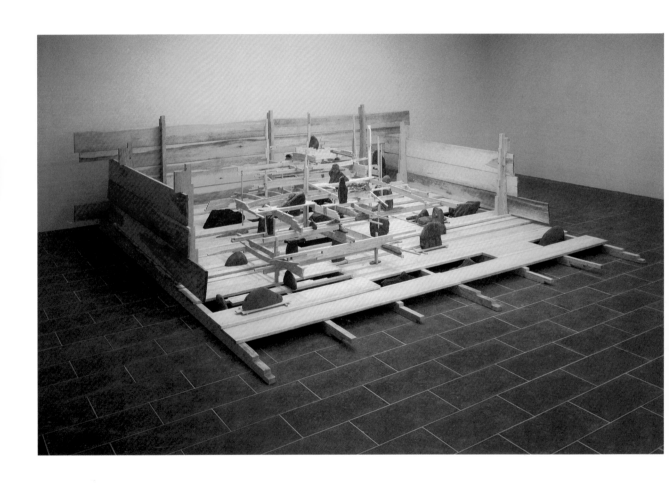

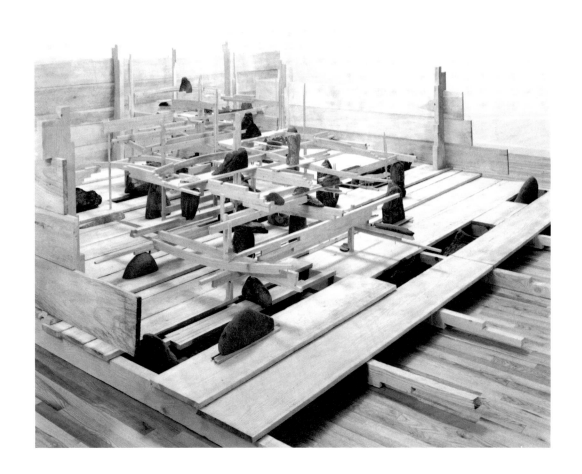

42. *Cloud Hands Ritual Series 1982.* 1982
Fungus and algae on pine and rocks,
40 × 168 × 96"
Courtesy Sperone Westwater, New York

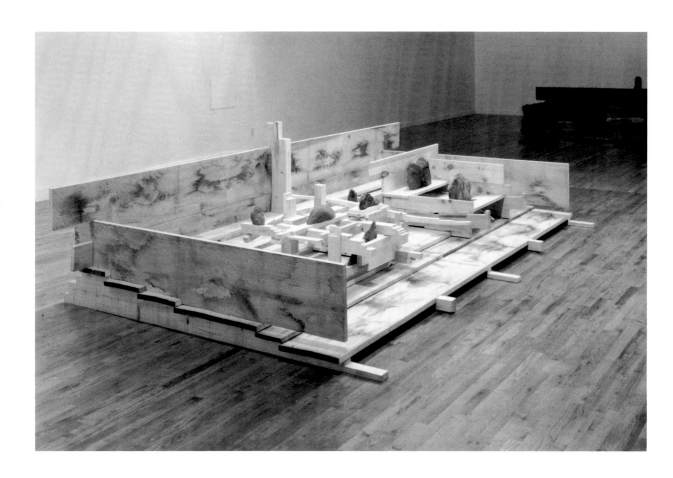

43. *Ritual Series 7/82.* 1982
 Rocks and wood with earth and straw,
 40 × 132 × 72″
 Courtesy Sperone Westwater, New York

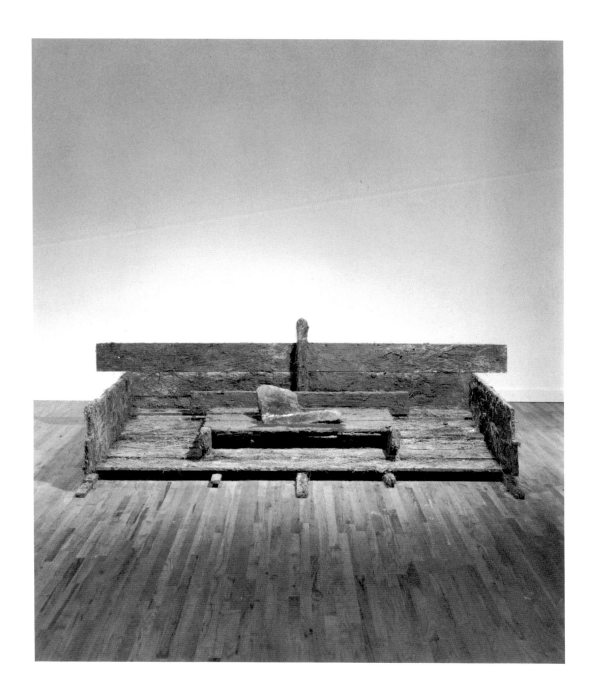

44. *Ritual Series 11/27/81.* 1981
 Paper collage, charcoal and chalk on paper,
 51 × 39″
 Collection Felice and Edward J. Ross, New York

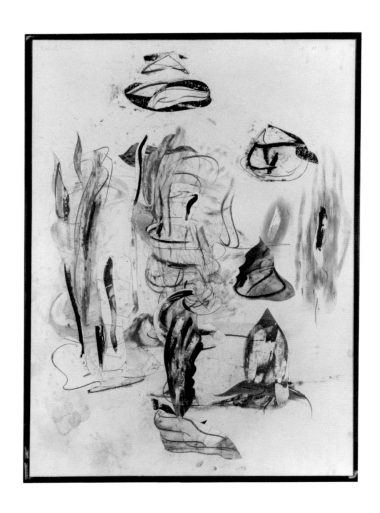

45. *Ritual Series 1982.* 1982
 Pine and rocks, 48 × 180 × 144″
 Courtesy Sperone Westwater, New York

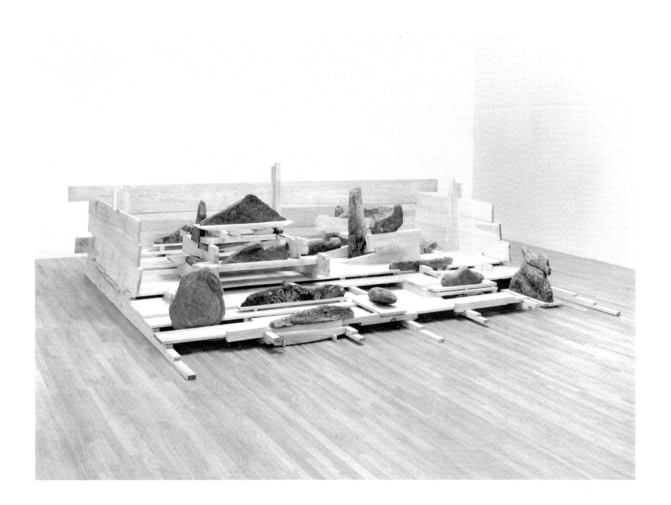

46. *Seven Moon Ritual Series 3/16/82.* 1982
 Paper collage, charcoal and chalk on paper,
 50 × 38″
 Courtesy Sperone Westwater, New York

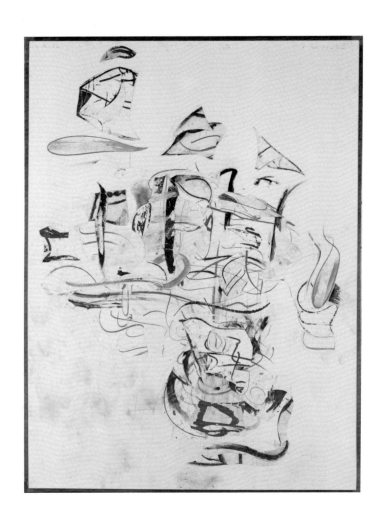

*47. *First Gate Ritual Series 1982.* 1982
 Granite, slate and fieldstones, 30 × 144 × 72″
 Collection of the artist, courtesy Sperone
 Westwater, New York

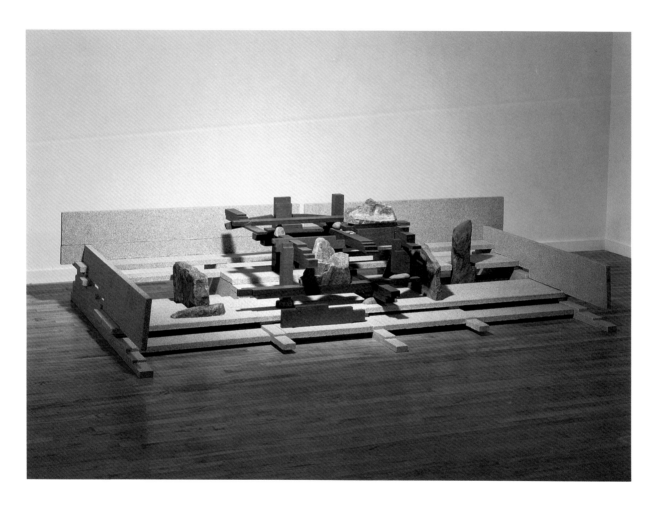

*48. *Seven Moon Ritual Series 1983*. 1983 (detail)
Granite and fieldstones, 33 × 240 × 72"
Collection of the artist, courtesy Sperone
Westwater, New York

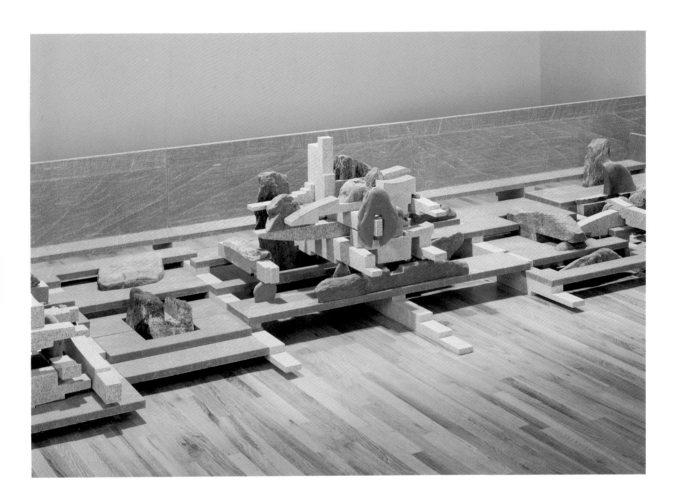

Seven Moon Ritual Series 1983. 1983

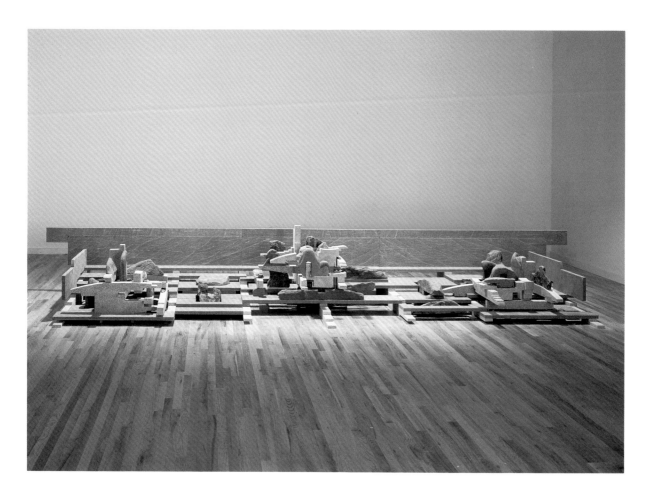

BIOGRAPHY

Born in Brooklyn, New York, 1945

Cornell University, Ithaca, New York, 1963-67, BFA

Yale University Norfolk Program, Norfolk, Connecticut, 1966

Rutgers University, New Brunswick, New Jersey, graduate study, 1968

Theodoron Award, Solomon R. Guggenheim Museum, New York, 1971

CAPS Grant, New York State Council on the Arts, 1972

Artist in Residence, State University of New York Convocation, Skidmore College, Saratoga Springs, 1973

National Endowment for the Arts Fellowship, 1974

Artist in Residence, Everglades National Park, Homestead, Florida, 1975

Artist in Residence, Palisades Interstate Park, Bear Mountain, New York, 1975

John Simon Guggenheim Foundation Fellowship, 1976-77

CAPS Grant, New York State Council on the Arts, 1979

Building Arts Grant, National Endowment for the Arts, 1980

Art Resources Center, Whitney Museum of American Art, *Work from the Whitney Museum's Art Resources Center*, June 9-July 19, 1970

Hudson River Museum, Yonkers, New York, *Light and Environment*, December 1970

Finch College Museum of Art, New York, *Projected Art: Artists at Work*, March 13-May 2, 1971

Solomon R. Guggenheim Museum, New York, *Ten Young Artists: Theodoron Awards*, September 24-November 7, 1971. Traveled to Hopkins Center, Dartmouth College, Hanover, New Hampshire, January 7-31, 1972; Contemporary Arts Center, Cincinnati, April 6-May 6; University of Alabama, Tuscaloosa, June 5-July 3; La Jolla Museum of Contemporary Art, California, August 31-October 8; Vancouver Art Gallery, British Columbia, Canada, November 14-December 14. Catalogue with text by Diane Waldman

Solomon R. Guggenheim Museum, New York, *Museum Collection: Recent American Art*, May 11-September 7, 1975

The Renaissance Society at the University of Chicago, *Ideas on Paper*, May 2-June 6, 1976

Nassau County Museum of Fine Art, Roslyn, New York, *Nine Sculptors: On the Ground, In the Water, Off the Wall*, May 2-July 25, 1976

Newcomb College, Tulane University, New Orleans, *Drawing Today in New York*, September 2-23, 1976. Traveled to Sewall Art Gallery, Rice University, Houston, October 8-November 19; Southern Methodist University, Dallas, January 10-February 16, 1977; University Art Museum, University of Texas at Austin, March 1-April 1; Oklahoma Art Center, Oklahoma City, April 15-May 15; Dayton Art Institute, June 3-August 21. Catalogue with text by Patricia Hamilton and Check Boterf

Kassel, West Germany, *Documenta 6*, June 24-October 2, 1977. Catalogue with text by Manfred Schneckenburger

Bear Mountain Inn, Bear Mountain, New York, *Artists in Residence 1975, 1976, 1977*, October 29-November 6, 1977. Catalogue with text by Alan Gussow

Hurlbutt Gallery, Greenwich Library, Connecticut, *Carl Andre, Dan Flavin, Donald Judd, Richard Long, Brenda Miller, Michael Singer*, February 2-26, 1978

Sperone Westwater Fischer, New York, *Drawings and Other Works on Paper*, February 18-28, 1978

Sperone Westwater Fischer, New York, June 9-September 23, 1978

Touchstone Gallery, New York, *Sculptors' Drawings*, January 6-31, 1979

Bell Art Gallery, List Art Center, Brown University, Providence, Rhode Island, *Invitational*, February 1-24, 1979

Whitney Museum of American Art, New York, *1979 Biennial Exhibition*, February 6-April 8, 1979

Albright-Knox Art Gallery, Buffalo, *Eight Sculptors*, March 16-April 29, 1979. Catalogue with text by Douglas G. Schultz

Wenkenpark Riehen/Basel, Riehen, Switzerland, *Skulptur im 20. Jahrhundert*, May 10-September 14, 1980. Catalogue with text by Reinhold Hohl

XXXIX Biennale di Venezia: Drawings—The Pluralist Decade, opened June 1, 1980. Catalogue. Traveled to Institute of Contemporary Art, University of Pennsylvania, Philadelphia, *Drawings—The Pluralist Decade*, October 4-November 9. Catalogue with text by Janet Kardon

Fort Worth Art Museum, Texas, *Aycock/Holste/Singer*, November 15, 1980-January 4, 1981

Solomon R. Guggenheim Museum, New York, *Contemporary Americans: Museum Collection and Recent Acquisitions*, January 22-April 12, 1981

The Aldrich Museum of Contemporary Art, Ridgefield, Connecticut, *New Dimensions in Drawings 1950-1980*, May 2-September 6, 1981. Catalogue with text by Richard Anderson

Kunsthaus Zürich, *Mythos & Ritual in der Kunst der 70er Jahre*, June 5-August 23, 1981. Catalogue with text by Erika Billeter

Heckscher Museum, Huntington, New York, *6 Decades: Collecting*, June 21-July 26, 1981

Sewall Art Gallery, Rice University, Houston, *Variants: Drawings by Contemporary Sculptors*, December 2-12, 1981. Traveled to Art Museum of South Texas, Corpus Christi, December 31, 1981-January 28, 1982; Newcomb College, Tulane University, New Orleans, February 9-19; The High Museum of Art, Atlanta, March 26-May 2. Catalogue with text by Laura W. Russell

Würtembergischer Kunstverein Stuttgart, *Natur-Skulptur*, 1981. Catalogue with text by Andreas Vowinkel

City Gallery, New York, *Made in New York*, February 1-17, 1982

Summit Art Center, Summit, New Jersey, *Drawing — New Directions*, March 17-April 8, 1982

National Museum of American Art, Washington, D.C., *Awards in the Visual Arts I*, May 7-August 8, 1982. Traveled to Des Moines Art Center, November 8-December 26; Denver Art Museum, February 2-March 22, 1983. Catalogue

The John and Mable Ringling Museum of Art, Sarasota, Florida, *Common Ground: Five Artists in the Florida Landscape*, May 14-July 18, 1982. Catalogue with text by Michael Auping. Text reprinted in *Ringling Museums*, vol. 15, June 1982

The Gallery of the Equitable Life Assurance Society of the U.S., New York, *Selections from Awards in the Visual Arts I*, April 11-28, 1983

Sperone Westwater, New York, *Merz, Nauman, Singer, Venezia*, May 14-June 18, 1983

Solomon R. Guggenheim Museum, New York, *Recent Acquisitions*, July 22-September 25, 1983

Sperone Westwater, New York, December 10, 1983-January 7, 1984

Zilka Gallery, Wesleyan University, Middletown, Connecticut, *Large Drawings*, January 26-March 9, 1984. Catalogue with text by Jean E. Feinberg

Sperone Westwater Fischer, New York, December 6, 1975-January 3, 1976

Wadsworth Atheneum, Hartford, *Michael Singer: MATRIX 24*, September 11-November 30, 1976. Catalogue with text by Andrea Miller-Keller

Dalrymple Gallery, Smith College Museum of Art, Northampton, Massachusetts, *Works by Michael Singer*, February 18-March 10, 1977. Catalogue with text by Lucy Lippard

Art Museum of South Texas, Corpus Christi, July 1-September 4, 1977

Neuberger Museum, State University of New York at Purchase, *Michael Singer: Sculpture and Drawings*, September 25, 1977-January 1, 1978. Catalogue with text by Peter Rottmann

School of Visual Arts, New York, March 5-24, 1979

Portland Center for the Visual Arts, Oregon, May 4-June 10, 1979

University Art Museum, UCLA, Berkeley, *Michael Singer: MATRIX 25*, August-October 1979. Catalogue with text by Michael Auping

The Renaissance Society at the University of Chicago, *Michael Singer: New Work*, May 18-June 21, 1980. Pamphlet with text by Jean E. Feinberg

Galerie Zabriskie, Paris, *Michael Singer: Ritual Series Photographs and Drawings*, April 21-May 23, 1981

J. Walter Thompson Art Gallery, New York, 1983

John Russell, "Michael Singer Blends Nature with Art at a Show Here," *The New York Times*, December 27, 1975, p. 11

April Kingsley, "Sculpture Gets New Energy," *SoHo Weekly News*, January 1, 1976, p. 16

Tara Collins, "Michael Singer," *Arts Magazine*, vol. 50, February 1976, p. 11

Nancy Grove [review], *Arts Magazine*, vol. 50, February 1976, p. 20

Barbara Zucker [review], *Art News*, vol. 75, February 1976, pp. 110-112

Alan Gussow, "Let's Put the Land in Landscapes," *The New York Times*, Section 2, March 14, 1976, pp. 1, 29

Nancy Foote [review], *Artforum*, vol. XIV, March 1976, pp. 71-72

Susan Soper, "Art for the Outdoors," *Newsday*, April 30, 1976, pp. 4A, 5A

Benjamin Forgey, "Art Is Where You Find It; Even in the Marshlands," *Washington Star*, May 14, 1976, pp. C1, C4

Donald Kuspit [review], *Art in America*, vol. 64, July-August 1976, pp. 104, 105

Carter Ratcliff [review], *Artforum*, vol. XV, October 1976, p. 63

"Voll bespielt," *Der Spiegel*, February 28, 1977, p. 164

Elizabeth Baker, "Report from Kassel Documenta VI," *Art in America*, vol. 65, September-October 1977, p. 45

"The Younger Generation: A Cross Section," *Art in America*, vol. 65, September-October 1977, p. 90

David L. Shirey, "A One-Sculpture Show at the Neuberger," *The New York Times*, November 20, 1977

Kate Linker, "Michael Singer: A Position In, and On, Nature," *Arts Magazine*, vol. 52, November 1977, pp. 102-104

Jeanne Siegel, "Notes on the State of Outdoor Sculpture at Documenta 6," *Arts Magazine*, vol. 52, November 1977, p. 132

Benjamin Forgey, "Art out of nature which is about nothing but nature," *Smithsonian*, vol. 8, January 1978, pp. 62-69

Mark Stevens, "Browser's Delights," *Newsweek*, vol. XCII, November 13, 1978, p. 105

John Russell, "Michael Singer," *The New York Times*, November 17, 1978, p. C19

Bee Maeve, "The Gallery Connection," *Ocular*, vol. 3, Fall 1978, pp. 60, 65

Benjamin Forgey, "Art In and Of Nature," *Horizons USA*, no. 28, 1978, pp. 60-65

Frances Beatty, "Whitney Winter Biennial," *Art World*, vol. 3, February 16-March 16, 1979, pp. 1, 12

Robert Hughes, "Roundup at the Whitney Corral," *Time*, vol. 113, February 26, 1979, pp. 72-73

Lindsay Stamm Shapiro, "Michael Singer," *Craft Horizons*, vol. XXXIX, February 1979, p. 51

Margaret Sheffield, "Natural Structures: Michael Singer's Sculpture and Drawings," *Artforum*, vol. 17, February 1979, pp. 48-51

William Zimmer, "Art for the Me Decade," *SoHo Weekly News*, March 1, 1979, pp. 39, 41

Sharon Edelman, "Sculpture Show Weaves Art and Architecture," *Buffalo Evening News*, March 20, 1979, Section IV, p. 57

Richard Huntington, "Albright Sculpture Exhibit a Treat," *Buffalo Courier Express*, April 1, 1979

Walt McCaslin, "Just getting there is half the fun," *Journal Herald* (Dayton), April 14, 1979, p. 19

Richard Whelan, "Discerning trends at the Whitney," *Art News*, vol. 78, April 1979, pp. 86-87

Wade Saunders, "Art, Inc.: The Whitney's 1979 Biennial," *Art in America*, vol. 67, May-June 1979, p. 99

Thomas Albright, "Disintegrating Sculpture and Relics," *San Francisco Chronicle*, September 5, 1979

Suzaan Boettger, *Daily Californian*, vol. 10, September 21, 1979, p. 14

"Ritual Series," *Zero*, vol. 3, Los Angeles, 1979, pp. 56-65

Kenneth Baker, "Hewing to the line: Sculpture for meditation," *The Boston Phoenix*, February 12, 1980, Section 3, p. 12

Øystein Hjort, "Mot en ny sensibilitet: Naturen i konsten-konsten i naturen," *Paletten*, 2/80, Göteborg, Sweden, pp. 30-32

Bill Marvel, "Unlikely trio puts on stunning show," *Dallas Times Herald*, November 28, 1980, pp. 1, 6

Nathan Knobler, *The Visual Dialogue*, New York, 1980, pp. 211-213

Peter Blum, "Michael Singer: Das Kunstwerk in der Natur-Die Natur als Kunstwerk," *du*, no. 6, 1981, pp. 60-70

John Caldwell, "Contemporary Artists in Summit Exhibit," *The New York Times*, March 28, 1982, p. C8

Deborah C. Phillips, "Michael Singer," *Artnews*, vol. 81, March 1982, pp. 208-209

Donald B. Kuspit, "Caves and Temples," *Art in America*, vol. 70, April 1982, pp. 129-133

Marcia Corbino, "Common Ground: 5 Artists in the Florida Landscape," *Sarasota Herald-Tribune*, May 19, 1982, p. 4C

Kurt Loft, "Five Artists Find Common Ground in New Exhibit at Ringling Museum," *The Tampa Tribune*, June 16, 1982, pp. 1D, 2D

Marsha Fottler, "Contemporary Sculpture Shows Respect for Surroundings," *Herald Tribune*, June 25, 1982, p. 4C

Carter Ratcliff, "A Season in New York," *Art International*, vol. XXV, September-October 1982, pp. 57-58

Jean E. Feinberg, "Michael Singer: Ritual Series," *Arts Magazine*, vol. 57, June 1983, pp. 69-73

Albright-Knox Art Gallery, Buffalo

Australian National Gallery, Canberra

The Chase Manhattan Bank Collection, New York

Fort Worth Art Museum

Solomon R. Guggenheim Museum, New York

Louisiana Museum of Modern Art, Humlebaek, Denmark

The Metropolitan Museum of Art, New York

The Museum of Modern Art, New York

O'Melveny & Myers, Los Angeles

Paine Webber Inc., New York

The Prudential Insurance Company of America, Newark

Joseph E. Seagram & Sons Inc., New York

Yale University Art Gallery, New Haven

PHOTOGRAPHIC CREDITS

Color

Joseph deCarlo: cat. no. 47

Courtesy Louisiana Museum, Humlebaek, Denmark: cat. no. 41 left

Michael Singer: cat. no. 28

David Stansbury: cat. nos. 40, 48 left and right

Black and White

Rudolph Burckhardt, courtesy Leo Castelli Gallery, New York: fig. 1

Bevan Davies: cat. no. 25

Chris George: cat. nos. 20, 23, 24, 26, 29

Robert E. Mates: fig. 6

Peter Moore, New York: fig. 5

Courtesy The Museum of Modern Art, New York: fig. 7

Michael Singer: cat. nos. 1-9, 13-15, 18, 19, 21, 38

Photo and copyright Harry Shunk, courtesy Leo Castelli Gallery, New York: fig. 4

David Stansbury: cat. nos. 10, 12, 16, 22, 27, 30-37, 39, 40, 41 right-46

Exhibition 84/2

3,000 copies of this catalogue, designed by Malcolm
Grear Designers and typeset by Schooley Graphics,
have been printed by Eastern Press in March 1984
for the Trustees of The Solomon R. Guggenheim
Foundation on the occasion of the exhibition
Michael Singer.